EXPLORING
HISTORICAL
CAMBRIDGESHIRE

EXPLORING HISTORICAL CAMBRIDGESHIRE

ROBERT LEADER

First published 2014

The History Press
The Mill, Brimscombe Port
Stroud, Gloucestershire, GL5 2QG
www.thehistorypress.co.uk

British Library Cataloguing in Publication Data.
A catalogue record for this book is available from the British Library.

ISBN 978 0 7509 6032 8

Typesetting and origination by The History Press
Printed in Great Britain

CONTENTS

CHAPTER ONE

THE CALL
OF THE CAM

Cambridgeshire is a county of waterways, natural and man-made, creating a blue-veined jigsaw of rich greens under wide blue skies. All have their attractions, but none is as lovely, or more varied, than the Cam itself. The river winds through a gently undulating valley and farmlands, past the pinnacled, architectural glories of the city of colleges, and out into the vast flat fields of the peat-rich Fens.

There are, in fact, three rivers feeding the Cam, the Rhee flowing in past Barrington and Haslingfield from the west, the Granta flowing in through Linton and the Abingtons from the east, and the central Cam, born in Essex and flowing south to north. The Cam slides under the M11 to wriggle past the first Cambridgeshire villages of Ickleton and Hinxton.

All along the valley there are traces of Saxon, Roman, and even Neolithic occupation. The river has been fished and the land hunted and then farmed for thousands of years. Today the villages are peaceful and idyllic. Hinxton is small but delightfully photogenic. The thatched Church Green Cottages on the corner of the green contribute to a classic scene which includes the silver-spired church of St Mary and St John. Down by the river is the old white-boarded watermill, which is still opened on Sunday afternoons in the summer.

To go on to Duxford the narrow lane crosses the river by a shallow but fast-flowing ford. To most people Duxford means the magnificent Aviation Museum on the other side of the M11, but the village itself is well worth a visit. Again, the core of the old village is a charming little green, in sight of another church dedicated to St John, shaded by trees and surrounded by old cottages, some thatched and some tiled. There is another restored mill here, about a score of the ancient buildings are listed, and there are two or three

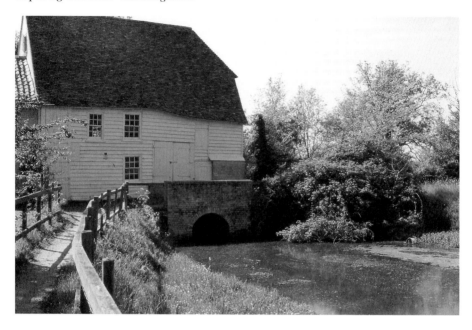

The old watermill at Hinxton.

lovely old pubs, including the thatched John Barleycorn, which had the date 1660 inscribed on its gable end.

Duxford is divided by the A505, and on the far side of the road is the magnificently rambling black and white timbered Red Lion pub. Tucked in close beside it is Duxford Chapel, a single hall of flint cobbled walls with a high pitched roof of small red tiles. Inside it is now bare, with a white dirt floor and an impressive high-timbered roof. It was last used as a barn, but it is in fact a rare survival of a mediaeval hospital chapel run by the Knights Templars. It offered shelter to poor travellers and tended to the sick. Its running costs were paid by revenues from a nearby watermill, and from tolls imposed for crossing the ancient Whittlesford Bridge.

From here tiny Whittlesford lies on the east bank of the river, and larger Sawston on the western side. At the heart of Sawston lies the parish church of St Mary, parts of it dating back to Norman times. The church nestles close beside Sawston Hall, which is encircled by a flint wall and hidden deep behind chestnut and plane trees. There is history here, for in 1542 Queen Mary stayed here while still a princess, but was forced to flee from a hostile Protestant mob. The story goes that she left the hall disguised as a dairymaid, protected by the hall's owner John Huddleston. The hall was set alight and burned down behind them. The Tudor mansion that was later built on the site is now the Cambridge School for Languages.

Great Shelford is the next large rambling village, with the A1301 slicing brutally through it. West of the road the Cam continues its winding way, between Great and Little Shelford, the latter a smaller gem with lots of lovely old cottages and the beautiful All Saints' church. Where the road loops over the bridge between the villages the river flows cool and green through archways of leafy trees.

Just east of Great Shelford and within sight of the southern environs of Cambridge are the Gog Magog hills, a low range of chalk hills which have now become a public park and a golf course. One legend says that Gogmagog was one of a race of 12ft-high giants who inhabited this region in prehistoric times.

Round about 250 BC there was a wave of invasion from France which caused the local population to build a great earthwork fort here with double barrier defences of ditches and stout timber palisades. The fort was called Wandlebury and it was stormed by the invaders. They came in chariots and it was possibly the first time that this new form of warfare had been seen in this part of the world. The new arrivals were the ancestors of the Iceni who later rebuilt the defences against the Romans, which proved another failed effort to hold back the tides of history. Some of the old half-mile circumference of ditches survives as the Wandlebury Ring.

After the fort had disappeared the land was used for grazing sheep. During the reign of James II horse-racing stables were built within the ring by the 2nd Earl of Godolphin. The stable block still remains with a notable cupola clock tower.

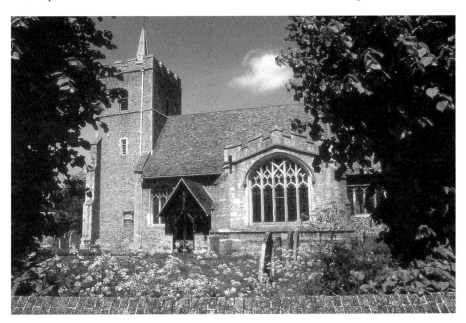

All Saints' church at Little Shelford, another Cam Valley jewel.

Godolphin also built his home here and created a park for his own pleasure. The house has vanished but the park remains, now under the care of the Cambridgeshire Preservation Society. Three nature trails have been established with over 200 species of wildflower, a wide variety of bird life and the possibility of glimpsing a fox, a vole or even a muntjac deer.

The main road crosses the Cam again at Grantchester with more access points down to the river. Just before the bridge here there is a signed footpath to Byron's Pool, a walk on a wide footpath through ivy-wreathed woods which comes out on a small weir where the river flows fast. Here the Rhee comes in from the far side to join the Cam. A short walk further up the riverbank and there is a slow cool bend, overhung with willows. This is where Byron, and a whole host of other poets, Brooke, Chaucer, Spenser and Milton, are all believed to have sat to contemplate their muse. A thoughtfully placed seat now allows modern poets to seek their inspiration without suffering the chill of the damp riverbank.

Grantchester is of course the best known of all the Cam Valley villages, being so close to Cambridge and a favourite haunt of tutors and undergraduates alike. It is another delight of thatched roofs and timbered buildings, of pastel-coloured plaster, and good ancient pubs. The Red Lion is painted rust red with high gables and a splendid array of thatched roofs and window overhangs. Beside it there is access to the Cam again, where picnickers lay on the sun-warmed grass, and the punts from Cambridge pole up to enjoy the lazy summer afternoons.

From Grantchester you can follow the footpath along the riverbank into Cambridge, where the river winds through the heart of the city on its spectacular way through the backs of the colleges. Here the punts pole back and forth in idyllic profusion whenever the weather is warm, filled with lounging students and visitors, and creating magical pictures of an elect, youthful paradise under a series of splendid bridges.

The Mathematical Bridge looks like a rustic timber jigsaw. It was designed by a mathematician named William Etheridge in 1749 and was constructed without the use of any form of nails. No one could work out how it was done so at the beginning of this century it was dismantled in an effort to find out. Those who took it apart were still baffled and had to resort to using nails to put it together again. This is the story the tour guides tell but other sources claim that the bridge was always secured by nuts and bolts. The idea of the ghost of old William Etheridge laughing at the baffled confusion of his successors is apparently a pleasing fiction.

Clare Bridge is solid, balustraded stone, Trinity Bridge is another stone-arched gem, and the Bridge of Sighs at St John's is designed in imitation of its namesake in Venice. As the punts pole their lazy way beneath them each one opens up a view of the next in line.

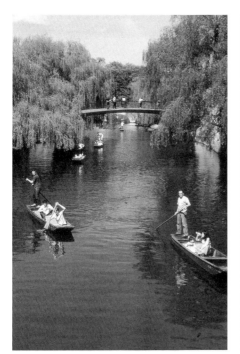

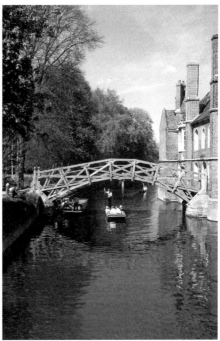

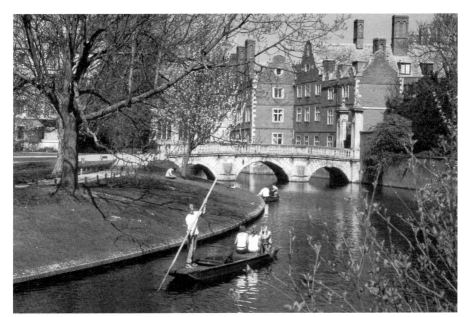

Clockwise from top left:
The Cam at Cambridge, where the punts pole to and fro in idyllic profusion.

The Mathematical Bridge at Cambridge.

Poling downstream toward St John's College.

The Backs have to be the most splendid stroll along the whole length of the Cam. In Spring there are rows of magnificent red tulips and cascades of white and pink blossom framing the wide green lawns, and on the far side of the river rise the colleges themselves in an almost fairy tale array of soaring pinnacles and spires. Most of the bridges give access into the college grounds, and then into the heart of the city, but there lies a wealth of detail for another chapter.

The river leaves the colleges as it passes under Magdalene Bridge, and then curves in wide loops around Jesus Green, Midsummer Common and Stourbridge Common before finding its way out through Fen Ditton Meadows toward the Fens. We are now on the Fen Rivers Way, where you can walk all the way to Ely.

The Cam becomes wider as it snakes through the flat fields, beyond its banks the landscape is rich green with crops on peat dark soil. The drained farmland of Cambridgeshire is now some of the best in the country and will grow almost anything. There are great swathes of sugar beet, potatoes, celery, wheat and carrots, the red gold of the Fenlands. This vast patchwork of agricultural produce lies under wide blue, cloud-rolling skies.

After 6 miles or so the Cam passes by Waterbeach, where once there were two great abbeys within the parish boundaries. Waterbeach Abbey has vanished now, but Denny Abbey remains as an English Heritage site and farmland museum.

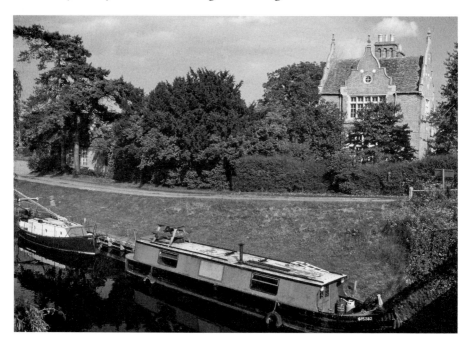

Narrowboats moored at Waterbeach.

There are traces of an ancient canal here built by the Romans, for this stretch of the Cam has always been an important transport route. Now long narrowboat barges are moored on either side of Clayhithe Bridge. There is a huge old cream-coloured pub here, called appropriately The Bridge, serving road and river traffic, and pleasure boats line the bank for 200 or 300yds, leading up to the neat green lawns of the Cam Sailing Club. This side of Cambridge the river is deep and wide enough to cruise.

The Fens to the north of Cambridge were once a watery wilderness, but the Cam has always provided a major artery for through traffic to and from the Great Ouse and the sea. Its second major function has always been in helping to drain the Fens and today a thousand cuts and ditches continue the work of carrying surplus water into the river, leaving behind rich arable farmland and grazing land.

This stretch of river, from Clayhithe back to Jesus Lock has been run by a body called the Cam Conservators since the passing of an Act of Parliament in 1702. They were given the right to charge tolls to pay for work to improve navigation, and in 1842 were able to build the impressive house with high Dutch gables that still stands on the east bank beside the road bridge. The house has a large meeting room where rich banquets were held until the river traffic and profits from the tolls all faded away with the coming of the railways and improved roads. However, the Conservators still care for this stretch of the river, balancing the twin needs for it to be shallow enough to take away the winter floodwaters, yet deep enough for the summer sailors.

The river is now managed to include more leisurely pursuits, for walkers and wildlife spotters along the riverbank footpaths, as well as the fishermen and the boating fraternity. It winds on slowly under the vast blue sky, to join with the Great Ouse which will carry its waters on to the Wash and out into the sea.

CHAPTER TWO

THE RIVER OUSE,
ST NEOTS TO ST IVES

Many years ago a friend of mine kept a boat moored at Littleport, and we spent many lazy summer weekends cruising up and down the Great Ouse, drifting leisurely through the Fens and into Huntingdonshire, and getting to know all those lovely old riverside pubs along the way. 'Drift through time' is how the current tourist brochures promote the three sister towns of St Neots, Huntingdon and St Ives, and somehow the placid mood of the river captured us and we never did find the time or inclination to stray far from the waterside. Only recently have I discovered how much we had missed.

It is now possible to walk the whole of the Ouse Valley Way, from Brackley in Northamptonshire to Kings Lynn in Norfolk where the river flows into the sea. It is a magnificent 156 miles, with a 26-mile stretch winding through the beautiful Huntingdonshire countryside. Almost every step of the way you will be accompanied by swans, white graceful adults and fluffy brown cygnets. The three market towns all seem to have them floating around their quaysides in abundance, all waiting to be hand-fed.

The Great Ouse enters Huntingdonshire at Eaton Socon, passing the attractive River Mill Marina, which is centred round the converted nineteenth-century mill. On the east side of the river is the core parish of ancient Eynesbury with its lovely old twelfth-century church. The river then flows on through the new extended town of St Neots. Eynesbury can date its heritage back through Saxon and Roman times, and as part of the kingdoms of the ancient Iceni, but St Neots can only boast a history of a mere thousand years or so. On the west bank here is the Riverside Park, with its walks and picnic greens, graceful weeping willows and white arched bridges. The Ouse River Bridge will take you over the river and straight into the town's ancient Market Square.

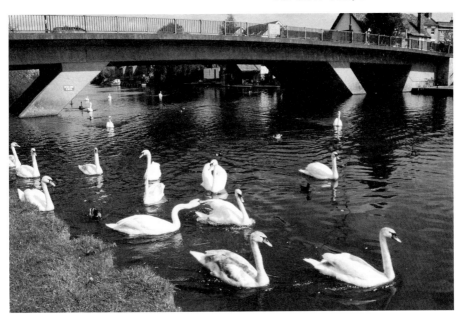

Swans gather at the old bridge at St Neots.

As you cross the bridge you can pause to imagine the short but ferocious battle which erupted here during the English Civil War. A Royalist force under the command of the Earl of Holland had occupied and claimed the town for the Crown. The Parliamentarians were having none of it and soon launched an attack. They won the day, and the unfortunate earl was captured and later beheaded.

The town itself had its beginnings in the small priory that was founded on the outskirts of Eynesbury toward the end of the tenth century. This was an age of devout pilgrimage and the veneration of saintly relics, and so the abbot of the new priory soon decided that to draw in the crowds and boost the priory coffers it was necessary to acquire a few suitable bones. There were no acknowledged saints buried locally in Huntingdonshire, so it was also necessary to look further afield.

Saint Neot, who was buried in Cornwall, seemed to be ideal. Neot had been a monk at Glastonbury, and it is possible that he may have been a brother or close relative of King Alfred the Great. He had become a hermit in Cornwall before founding a small monastery there, and after his death he had been named as a saint.

The good monks of Huntingdonshire succeeded in stealing Saint Neot's bones. The irate Cornishmen followed in hot pursuit, but the king favoured the Huntingdon side and the royal soldiers forced the Cornishmen back. The bones were interred in St Neot's new priory beside the Great Ouse River and the town flourished.

The priory is now long gone, it was completely demolished at the time of the Dissolution, but the town remains and its market still thrives. In later times it was the river itself, the stagecoach routes and then the railways that brought continuing prosperity. The old Cross Keys inn on the High Street facing the market was a coaching inn on a site where an earlier structure once served mediaeval pilgrims. Only the façade remains now, forming the entrance to a small shopping mall. Times have changed, but there are echoes of St Neots that seem timeless. Its huge parish church of St Mary is sufficiently impressive to have been nicknamed as the 'Cathedral of Huntingdonshire'.

The Great Ouse flows on, past Paxton Pits Nature Reserve, where you can look for butterflies and herons around the maze of lakes, woodlands and grassland meadows. On the west side is the charming little village of Great Paxton where the lovely old church of the Holy Trinity is said to be one of the oldest in England.

The river reaches Offord Lock, and the old Flour Mill by the bridge that has now been converted into modern flats. Buckden Marina is just around the corner, and nearby is the village of Buckden with those glorious red-brick Buckden Towers standing tall behind the high tower and spire of the parish church of St Mary.

The towers, together with the massive inner gatehouse and parts of the old battlemented walls are all that remains of the magnificent moated palace of the Bishops of Lincoln. The palace, and its position on the Great North Road, made Buckden into a thriving village with a long and chequered history. The rambling Lion Hotel on the crossroads corner was once a guest house for the palace, and later became another popular coaching inn.

Many royal visitors have stayed at Buckden Palace as guests of the bishops but the most famous visitor of them all was virtually a prisoner. Catherine of Aragon, the first wife of Henry VIII was sent there by the king's order after the annulment of their marriage in 1533. Catherine found the villagers of Buckden sympathetic to her plight and her devoted attendants continued to treat her as a queen. This annoyed Henry so much that he sent the Duke of Suffolk to move her.

Catherine refused to be moved. She retired to her room and sealed the door against the frustrated duke. Suffolk arrested some of her attendants and had her furnishings packed up ready to send away with her, but the adamant Catherine remained in her locked room. By this time the people of Buckden had got wind of what was happening and a large crowd of villagers had gathered outside the palace. They were silent and made no move but most of the men carried choppers or billhooks and their presence was an unspoken threat.

Suffolk realised that he could only move the unwilling queen by force and clearly he would be opposed. He found himself shunned by the local gentry so no help would be found there. After several days of stand-off the Duke decided on discretion as the better part of valour and returned to admit his defeat to London.

Catherine was later removed to Kimbolton Castle, but to much more comfortable and acceptable quarters than those that Suffolk had been able to offer.

The river continues in a peaceful flow to Huntingdon, passing through Godmanchester with its delightful white, humpback Chinese Bridge. Here, at another important crossing point of the river, is the second of the three sister towns, made the most dominant in the Middle Ages when William the Conqueror ordered the rebuilding of its castle.

Before that the Saxons had settled, and the Danes had built extensive earthworks. The Normans enlarged upon those with a powerful motte and bailey to overlook the river. Only a park remains now, between the old arched stone bridge to Godmanchester and the new bridge carrying the A14. The highest point of the park, a grassy knoll where once the keep might have stood, now supports a beacon, but there is nothing else.

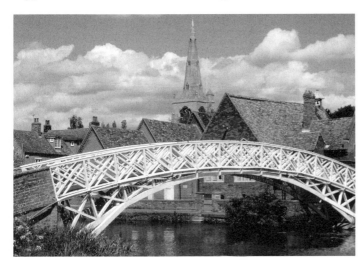

Godmanchester and the Chinese Bridge.

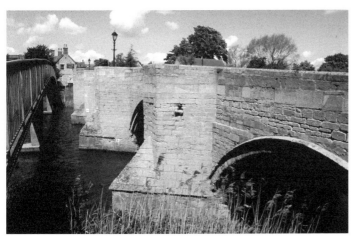

The old stone bridge and the new footbridge at Huntingdon.

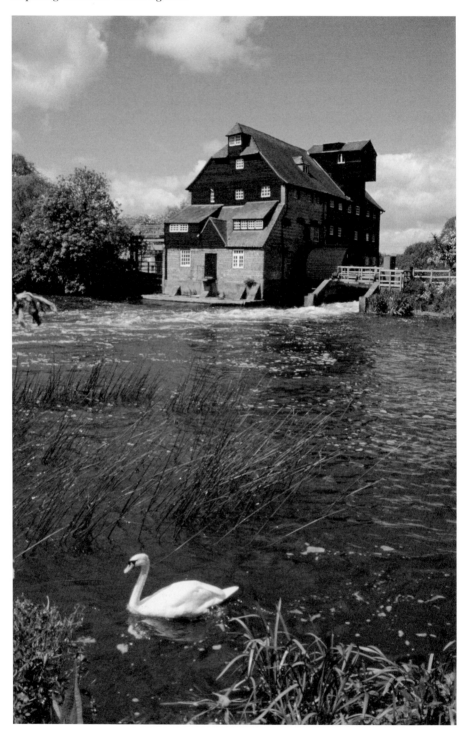

Houghton Mill.

The way up from the old bridge leads into the busy High Street, and inevitably to the Market Hill. On the way you will pass St Mary's church, almost completely rebuilt in the thirteenth century, and above the market stands All Saints. At the peak of its prosperity in the thirteenth century, Huntingdon is said to have had sixteen parish churches, but only these two remain. The Black Death hit Huntingdon particularly hard in the fourteenth century, and its trade and fortunes declined.

However, today it is thriving again, helped no doubt by the continuing presence of the river and the new marinas serving the tourist and holiday trade.

The river meanders on, past Houghton's ancient watermill on its island in mid-stream, and the richly picturesque villages of Hemingford Abbots and Hemingford Grey on the west bank. Finally it reaches St Ives, the last of the three ancient market towns that line its Huntingdonshire banks.

St Ives is also named after a saint, a mysterious Persian bishop named Ivo who came to England as a Christian missionary in the seventh century. His bones were also purloined, but only moved as far as Ramsey Abbey. His name remained with the town that had grown up around this one-time ford across the Great Ouse.

The ford here was important because at one time it was the last possible crossing place before the river disappeared into the dangerous marshes of the Fens. There is a flint ridge across the riverbed which created the ford and later became the foundation for its bridge.

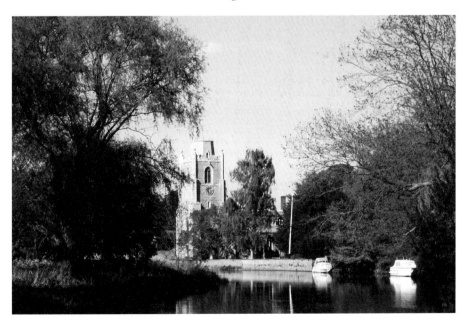

The church and the river at Hemingford Grey.

Now a handsome six-arch stone bridge stands here, with the small stone chapel of St Ledger in the centre. In more dangerous mediaeval times the chapel was a last chance for travellers to pray before leaving the safety of the town, or to give thanks upon reaching it.

During the Civil War the bridge was blown up by Oliver Cromwell. It was done to stop the troops of King Charles I who were marching from their Royalist base in Lincolnshire and heading for London. For a while there was only a wooden drawbridge to close the gap, but after the war the bridge was rebuilt. The southern two of the five arches are consequently of a slightly different shape to the other three, being slightly rounded and less gothic.

Now the bridge is occasionally used for services, but, as one of only four surviving chapels of its kind in the country, it is better known as a tourist attraction.

Head into the centre of town from the bridge and again you will come straight to the High Street and the Market Place. King Henry I granted a charter for a fair to be held here in 1110, and for the next 400 years it was the annual scene of one of the biggest week-long events in the country.

In the nineteenth century the town was so busy that there were sixty-four inns and public houses catering for the thirsty floods of farmers and traders who invaded the town on every market day. As livestock sales eventually diminished the number of pubs also went slowly down and by 1962 there was a low point when only seventeen pubs were open. The oldest was the Dolphin which had lasted for 400 years; next came the White Hart, the Nelson and the Lion's Head, which can all be dated back to 1720.

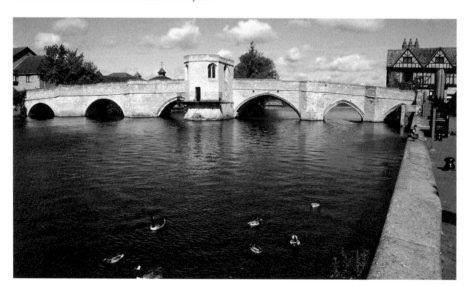

St Ives, the River Bridge and St Ledger's chapel.

Now the market has the addition of a bronze statue of Oliver Cromwell dominating the stalls beneath the elegant spire of the United Reformed Free church. The Monday market still takes over the town centre and there is a Friday Market and a Farmer's Market. The Michaelmas Fair still takes up three hectic days.

Just upstream on the riverbank is All Saints' church, marking the site of the original settlement before St Ivo's priory was built. The priory itself is again long gone except for the broken corner walls of one of its barns down near the quayside.

The whole history of the town can be found in the Norris Museum, situated in a calm and charming location on the river. Here you can see fossil bones of the Ichthyosaurs and Plesiosaurs, the monstrous marine reptiles which once swam overhead when Huntingdon was under the sea. Later, when the seas receded, woolly mammoths walked here and their tusks and bones are also preserved. The exhibits continue with relics of Stone Age man, the Saxons, the Vikings and the Romans, revealing an intriguing history from the ancient past right up to the present day.

Like Huntingdon and St Neots, St Ives is a charming old town to explore, and the river that links all three is lined with marinas and rowing clubs, riverside parks and pathways. This is paradise for fishing and boating, walking and wandering, with idyllic beauty and glimpses of history at every bend and turn.

CHAPTER THREE

ELY AND THE
GREAT OUSE

The Great Ouse leaves Huntingdonshire to wind down through Ely and beyond it enters the vast, lonely landscapes of the Fens. Once these wild and mysterious marshes were filled with waterfowl, reed-curtained waterways and lost mist-shrouded islands. All that has now changed, and when I began the first part of this journey it was a bright May morning, the flat fields were rich and green, the high sky a vibrant blue, the hedgerows lined with white May blossom and the road verges white with cow parsley.

Tales of colourful well-dressing ceremonies and a haunted inn led me to Holywell, where the river valley winds between the A14 and the A1123 between St Ives and Earith. Usually the drone of traffic from both roads can be faintly heard, but on this day there was no wind to carry the sounds, and all was breathtakingly peaceful and silent.

The ancient well, tucked close beside the churchyard wall, had a small brick shelter arched over it. The spring here is said to have been used by the Iceni in pre-Roman times, and later it became known as a holy well with properties that could heal blindness. The annual well dressing takes place in June.

Follow the road down past a series of large, beautifully thatched houses, with flowering gardens and manicured lawns, all of them much too grand to be called cottages, and you will come to the Ferryboat Inn. This rambling old white-painted brick and board building overlooks a small green landing space beside the wide curve of the river. It is one of the many ancient ferry crossing points along this stretch of the Ouse Valley, and an inn has stood here since the tenth century. Another is by the 300-year-old Pike and Eel inn just downstream at Needingworth.

The Ferryboat is said to be the oldest inn in England, so perhaps it is inevitable that it has to have a ghost story. There is actually a tombstone in the floor of the bar.

Here a young lady named Juliet Tewsley is said to sleep but not to rest. She drowned herself over an unrequited love affair, and was buried on the riverbank. Later the inn was built over her. It is 17 March which is said to be the unhappy girl's birthday and the fateful night when her wraith might just arise to drift over to the river.

However, untroubled by ghosts or possible hauntings, the river rolls blithely on. It swings north-east up to Earith, which mainly lies along the riverside road and has some nice waterfront houses and pubs. The Crown and the Riverview Hotel both have large beer gardens on the riverbank with mooring stages for boats.

The parish church is St Mary's, which serves both Bluntisham and Earith. It is a cosy little gem of a church with a tower and a spire, the churchyard and old tombstones casually overgrown with wild grasses and cow parsley, and deliberately left that way as a conservation area for insects, birds and wildlife. It makes a pleasant, sunny, and natural haven.

Earith has been called the Gateway to the Fens, and lies in the junction between the Great Ouse and the man-made Bedford Level. It was an important area in ancient times and nearby are the Bulwarks, the remains of ancient defensive earthworks which protected the Isle of Ely. More prominent today are the modern concrete piers and sluice gates that control the river junction.

Right: St Mary's at Bluntisham.

Below: Earith: the town sign marks its links with ice skating in the Fens.

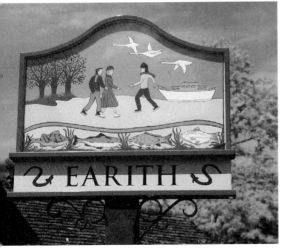

Earith was once a well-developed inland port, the name means 'muddy harbour', but Earith's more recent claim to fame is highlighted by the skaters on the frozen river, who are the prominent figures on the town sign. The meadowland can flood and freeze here in winter, and if the ice quality is good enough the English National Skating Championships can be held. Bury Fen and Little Fen, just below the church, are known as the place where the exciting new game of ice hockey first thrilled the crowds.

The river takes a wide south-easterly loop from here, swinging up again towards Ely and passing the Stretham Old Engine. The old, brown-brick pumping house with its tall brick chimney stands close by the riverbank. Inside is a coal-fired, steam-powered double-acting rotative beam engine, which was one of over 100 pump engines installed in the Fens, replacing over 800 windmills in the 1800s. Its task was to power a giant scoop wheel which lifted rainwater up from the sinking fields and into the river. For the next 100 years it continued the endless task of the old windmills, helping to drain the shrinking fens and prevent them from flooding, until it too was made redundant by a new diesel engine. Now four electric pumps carry on the great work, and the original engine is classed as a Scheduled Ancient Monument, lovingly preserved and maintained, and still capable of giving demonstrations of its former glory on designated public open days.

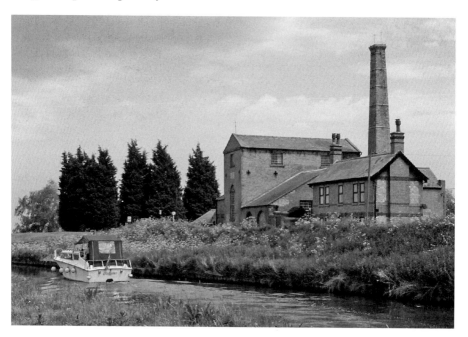

Stretham Old Engine: the pump house contains the earliest and finest example of the old steam engines once used to drain the Fens.

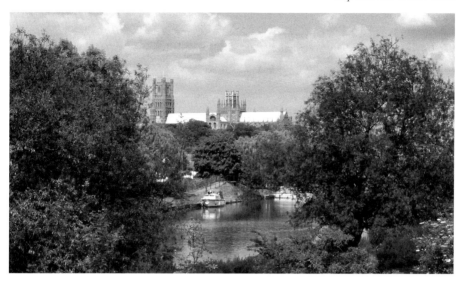

Ely Cathedral from across the Great Ouse.

If you want more there is another fascinating collection of old drainage engines at the Prickwillow Museum on the bank of the River Lark just a few miles from Ely. They are housed in the original Prickwillow Engine House which was built in 1890 in a picturesque setting on the riverbank. Here are six large drainage engines which have been rescued from Fenland pumping stations, including the original engine which was installed at Prickwillow in 1924. The collection is complemented by a range of smaller engines and an audio-video presentation which tells the story of the history and management of the Fens.

Heading almost due north now, lured by the majestic towers of the dominating cathedral, the great 'Ship of the Fens', the river comes to Ely. The town is dwarfed by the cathedral, which was founded by St Ethelreda as a double monastery for both monks and nuns in 673, with herself as the first abbess.

The site, which was once an island, has a chequered history. In 869 it was destroyed by the invading Danes, who looted and burned as they overran all of East Anglia. In 970 it was re-consecrated as a Benedictine monastery and the present cathedral was built towards the end of the next century. The monastery was dissolved by Henry VIII, but was re-founded as a cathedral and a school. Today, with its soaring West Tower and the splendid central octagon, it is the glory of the Fens and one of the most impressive sights in England.

The Isle of Ely was also, briefly, the last stronghold of Hereward the Wake, the last Saxon freedom fighter to defy William the Conqueror. Hereward held Ely until he was betrayed by the monks who showed his enemies a secret way through the marshes, probably in return for a promise that their monastery would be spared.

Another link with history is that Oliver Cromwell was once the Member of Parliament for Ely, before he became Lord Protector and executed his king. It seems that Cromwell's footsteps can be traced all along the Great Ouse, from his roots in Huntingdonshire to the lovely old black and white timbered house in Ely where he lived for ten years between 1636 and 1647.

Cromwell was the son of a country squire, born in Huntingdon where he went to school. For a while he was a student at Cambridge before moving to London to study law. There he met Elizabeth Bouchier who was to become his wife. They had five children and lived in Huntingdon and then St Ives before moving to Ely. Cromwell was a stern religious man, a true Puritan, and his statue in St Ives shows him with a sword at his hip and a Bible tucked under his arm.

Cromwell followed his father's footsteps, both as a gentleman farmer and then into politics. He became MP for Huntingdon and later for Cambridge. He might have had a dull but comfortable career if Parliament had not come into conflict with the king as all of England slid into civil war. Cromwell had to take a side and for him there was only one place to stand, his loyalty to the defiant king had to come second to the greater cause of Parliamentary reform.

The dons at Cambridge University decided to send their silver plate as a donation to finance the king. Cromwell moved fast to intercept it and the die was cast. Cromwell the gentleman farmer became Cromwell the soldier. He was made responsible for the defence of Huntingdon and Cambridgeshire which were then separate counties.

Cromwell proved a brilliant cavalry tactician and as a Captain of Horse took part in the Battle of Edgehill. The battle was indecisive but Cromwell's genius shone through and he was promoted to colonel. He was in the thick of the Battle of Newbury and afterwards was given the job of training new detachments of cavalry and then of reorganising the New Model Army as a whole. He was becoming dominant as both a soldier and a politician and was instrumental in winning a significant victory for the Roundheads at the Battle of Marston Moor.

Under Cromwell's leadership the Roundheads won victory after victory, especially with the help of his cavalry units which were nicknamed the Ironsides, and with a crushing defeat of the Royalist forces at Naseby the English Civil War was over. The king fled to Scotland but the Scots handed him back to the English Parliament who put him on trial for treason and found him guilty. Cromwell had made every effort to gain a compromise but in the end his was one of the signatures on the order that demanded the monarch's execution. King Charles I went to the block and there he was forced to kneel to the headsman's axe.

A re-enactment of Cromwell's Ironsides.

Cromwell was now commander-in-chief of the army, he put down Royalist insurrections which broke out in Wales and defeated the rebellions of the Scots at Preston and Warrington. He was virtually the military dictator of England and after the execution of the king was given the title of Lord Protector.

This dour and pious, Bible-quoting farmer had become the greatest historical figure ever to arise from the flat Fenlands of Cambridgeshire. The whole course of English history swirled and changed around him. When he died in 1568 Cromwell was buried in Westminster Abbey. His short-lived English Commonwealth virtually died with him and when Charles II was returned to power, Cromwell's corpse was dug up, hung in chains and beheaded. His revolutionary legacy remains, however, and a new age of parliamentary democracy had begun.

Oliver Cromwell's house close by St Mary's church became a vicarage, and is now a museum. Fittingly, among its attractions, is a permanent exhibition relating to the English Civil War. The study room there has Oliver Cromwell writing at his desk and the haunted bedroom portrays Cromwell on his deathbed. Cromwell is well remembered in Cambridgeshire and there is another Oliver Cromwell museum in Huntingdon.

The Great Ouse is very busy here at Ely, with marinas on either side. Narrowboats and pleasure cruisers line the waterfront where the Cutter Inn makes a welcome break from fishing and sailing. On a sunny day there is rarely a vacant table on the terrace overlooking the quays and the river.

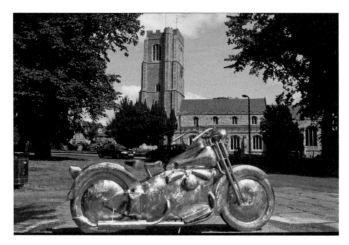

Littleport, the Harley-Davidson monument and St George's church.

Littleport is the last port of call in Cambridgeshire, and as its name suggests it too was once a small island port before the Fens were drained. Barges once stopped here on the way up from King's Lynn to Ely, but now there is a modern marina, the Boat Haven. There is also another lovely old riverside pub, the Black Horse, beside Sand Hill Bridge.

The most attractive part of town has to be the green opposite St George's church. Shaded by mature chestnut trees, on one side is the town's war memorial, and on the other is the silver sculpture of a Harley Davidson Motor Cycle which stands in a paved circle. The latter is a memorial to one William Harley who left Littleport to seek his fortune in America in 1860. His son, also named William, eventually co-founded the world-famous Harley Davidson Motor Cycle Company.

However, Littleport is even more famous for its rioters. The people rioted in the thirteenth century in protest against the drainage of the Fens, which they saw as a threat to their livelihoods as fishermen and wildfowlers. There were more riots after the Napoleonic wars, against the twin spectres of unemployment and starvation, and this time five of them were hanged and nineteen others deported to Botany Bay. The rioters were finally forced to surrender to the forces of the law at the Old George and Dragon pub. The pub is now demolished and a neat terrace of cream-painted cottages stands in its place, with just a small black plaque on the wall to commemorate what happened here.

The river winds on, to exit Cambridgeshire at Brandon Creek. The last part of its journey is through Norfolk before it reaches the North Sea, a great Fenland river with a wealth of history behind it and a thousand tales to tell.

CHAPTER FOUR

CAMBRIDGESHIRE ABBEYS

Before they were drained the Fens were a wilderness of marsh and water, a mist-sodden landscape of reed and rushes and dark haunted creeks and mudflats. They formed a world fit only for fish and wildfowl, and those wild marshmen hardy enough to live in reed huts and survive on such a diet. Here and there were a few more solid islands in the black peat bog, and these supported the first crude villages that were later to become the towns we know today.

However, the cruel isolation of those early islands formed the perfect setting for those who wanted to withdraw from life and worldly ways. They were a magnet for holy hermits and ascetics seeking solitude and contemplation, and eventually became the ideal location for monks and monasteries.

A classic example is Thorney, where the abbey church of St Mary and St Botolph still survives in evidence of 1,000 years of unbroken Christian worship. The magnificent two-towered west front, together with the nine saints carved into the topmost niches, dominates the centre of this small Fenland town. Inside the east window is a glory of stained glass, copied from the Trinity Chapel in Canterbury and showing in detail the miracles of St Thomas à Becket.

Thorney was originally a low island only rising a few metres above the surrounding fens and the name came from the Island of Thorns. Given its remote location and the vivid significance of the crown of thorns placed upon the head of Christ at his crucifixion it was a place destined to attract Christian mystics. The first ascetics came here to escape the world in the seventh century, and the island became known as Ancairg, or the Island of Hermits.

This first Christian settlement was destroyed by the rampaging Danes in AD 870. In the same orgy of destruction the Danes razed the nearby monastery

Thorney Abbey, the church from the green.

which stood on the site of what is now Peterborough Cathedral. Some of the monks of Thorney escaped with their lives and helped to bury the less fortunate monks of Peterborough.

Thorney was re-founded as a Benedictine abbey in 972 by Aethelwold, the Bishop of Winchester, and soon ornate new buildings in stone flourished to the greater glory of God. Daily life in the abbey was a balanced round of work, study and prayer, and the diligent copying of religious manuscripts. The monks themselves were bound by vows of poverty, but the abbots were shrewd men and the relics of St Botolph attracted visitors and donations, and so the abbey prospered for over 500 years until the Dissolution. The last abbot and the last twenty monks were pensioned off, many of the stone buildings were demolished and cannibalised and the church became a ruin.

Much later the vast task of draining the Fens brought in a wave of specialist workers and new tenant farmers, and to tend to their spiritual needs the old abbey church was restored and given a new lease of life.

Ramsey tells a similar story. It was another island in the Fens, a peninsular of gravel jutting out from a wilderness of marsh, and here a prior and twelve monks founded their abbey in AD 969. It was dedicated to Our Lady, St Benedict, and to all Holy Virgins. Later it was expanded on a much greater scale by a Norman abbot in the twelfth century, so much so that it eventually came to be called 'Ramsey the Rich'.

Ramsey seems to have escaped the depravations of the Vikings, but was not so fortunate in 1173 when the rebel baron, Geoffrey de Mandeville, needed a Fenland base he could defend against King Stephen. De Mandeville threw out the monks of Ramsey and turned their abbey briefly into a castle. However, he was struck down by an arrow while besieging Burwell Castle, and his rebellion died with him. Perhaps the prayers of the monks had been answered and their abbey was restored.

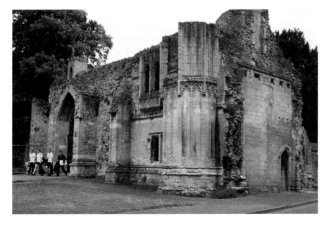

The ruined gatehouse of Ramsey Abbey.

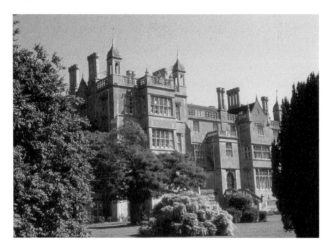

The modern Abbey Grammar School, built on the site of Ramsey Abbey.

Nothing could save the abbey from that all-consuming catastrophe, the Dissolution, and the ruined gatehouse is almost all that remains. The splendid mansion that is the modern Abbey Grammar School has been built over the mediaeval Lady chapel on the original site.

However, looking across the Abbey Green is the parish church of St Thomas à Becket, which was originally a hospitium, a hospital and guest house for pilgrims which was founded around 1180 and attached to the abbey. In those early days the ordinary people of the parish would have had the right to worship in the abbey church, but later the hospitium was consecrated, and eventually some of the stone from the dissolved abbey buildings went into the construction of the new church tower. All has changed, but there is calm reassurance in the knowledge that the old stones still echo with the sounds of worship.

Waterbeach, on the west bank of the Cam between Cambridge and Ely once had two abbeys within its parish boundaries. Waterbeach Abbey seems to have vanished almost without trace, but Denny Abbey still survives as an English Heritage site and a farmland museum. Part of the abbey buildings remain, and the long, thatch-roofed nun's refectory.

Denny has a varied history, having been founded as a Benedictine church, sold to the Knights Templars at the height of their power, and then changing hands again to become a Franciscan nunnery. The story began, as so many did, with a rich and powerful man, who to ensure the salvation of his soul, deemed it necessary to end his days as a monk, or to found a religious community. Robert, the Earl of Richmond, who owned the property that was to become Denny Abbey, did both. In 1159 he enabled a small handful of monks to establish their community as an offshoot of the great abbey at Ely, to which he then retired.

After only eleven years at Denny the monks returned to Ely and the church they had built was sold to the Templars, the soldier monks vowed to the

protection of pilgrims and the defence of Jerusalem. Denny became a hospital and retirement home for the Order until the middle of the fourteenth century when the bishops and monarchs of Europe began to resent their wealth and power and they were disbanded by the Pope.

The abbey buildings were then acquired by the Countess of Pembrokeshire, who restored it as an abbey for the order of Franciscan nuns known as the Poor Clares. When King Henry's axe fell it became a farmhouse.

Anglesey Abbey is not really an abbey at all, although it is built on the site of a twelfth-century Augustinian priory. It is a modern stately home, built in the twentieth century, although it does manage to look considerably older. The treasures of the house are eclipsed by its 98 acres of glorious gardens and parkland.

There were many of these priories scattered over Cambridgeshire. One remains at Isleham that was an outstation of an abbey in Normandy. These alien priories supported the foreign monasteries that controlled them, and when England went to war with France many, like Isleham, were seized by the Crown. Isleham was suppressed in 1414 and was then used as a barn.

One abbey which now sits just inside Lincolnshire on the northern county border is Crowland, which is an impressive ruin with high broken walls and broken arches. One part of it with a solid tower and short pyramid spire is still in use as the parish church. The remains cover only a third of the abbey's original area, and as a large and prosperous monastery its landholdings in the early Middle Ages would have extended well into what is now Cambridgeshire. It is still close enough to be well worth a visit.

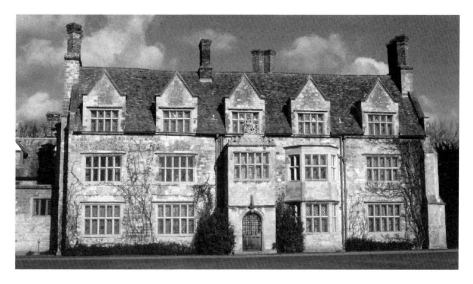

Anglesey Abbey is not really an abbey at all, although it is built on the site of a twelfth-century Augustinian priory.

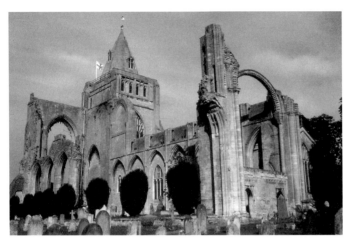

The ruins of
Crowland Abbey.

Thirteen centuries ago Crowland was another of those small islands in the middle of the marsh and wetlands of the inhospitable Fens and so another ideal place to establish a small hermitage and then a church. Solitude was always a prime aid to devotion but inevitably attracted more monks. In 716, King Aethelbad of Mercia is said to have founded the first monastery. It was destroyed by the Vikings around 950 in one of their brutal raids, a repetition of the now familiar Viking horror stories with the inevitable scenes of murder, burning and looting. However, Crowland was re-founded again to grow into one of Fenland's most important Benedictine monasteries. By the time of the Norman Conquest there was an immense, cathedral-sized church and spacious living quarters to house up to forty monks. Plus the abbey owned numerous estates given to it by pious benefactors who needed to make their peace with God.

The abbey prospered but not without some legal manipulation by the monks who, despite their vows of poverty, were not averse to some land-grabbing fraud. In 1413 a neighbouring abbey staked a claim to some of the Crowland lands, and to fight for ownership the monks of Crowland had to prove their case in court. They did so by presenting the royal court with their *Historia Crowlandensis*, which they claimed was a true history of the abbey which included details of all the land charters it now held. The history and the charters were ruled as legitimate and the monks of Crowland won their case.

The good brethren of Crowland had secured the future of their great abbey until the general termination of the Dissolution, and it was much later before their clever deception was discovered. By the eighteenth century the history had become a favourite source of research for scholars since it was seen as a rare written record covering centuries of mediaeval monastic life. However, in the nineteenth century historians began to have their doubts. They noticed

that records which were supposedly written in the tenth century were actually using terminology from the fourteenth century. The discrepancies added up to a major deception and it became clear that the whole thing was an elaborate hoax. The monks of old had perpetuated an elegant con trick.

However, Cambridgeshire's two great glories linking back to the monastic age are without doubt the magnificent cathedrals at Peterborough and Ely. As we have seen, the first monastic church at Peterborough was destroyed by the Danes who also attacked Thorney. The church was rebuilt as part of a new Benedictine abbey and re-consecrated in 972. Again it was destroyed, this time in an accidental fire, in 1116. Faith was not to be denied and again it was rebuilt. After the Dissolution the monastery church survived to become the cathedral for the new diocese of Peterborough, with the last abbot changing his role to that of the first bishop.

Ely, the great stone 'Ship of the Fens', was founded as a double monastery for both monks and nuns by Ethelreda, the daughter of the King of the East Angles in 673. Ely was also pillaged and burned by the merciless Danes, but here too the monastery was rebuilt and reborn. After the Norman invasion, Hereward the Wake led the remnants of Saxon resistance from almost impregnable Ely. It was a brave fight until the last Saxon abbot surrendered the monastery. After that, successive Norman abbots built Ely into the towering monument we see today.

The heartland of Cambridgeshire and the Fens has nurtured Christianity for 1,400 years, from the first hermits seeking solitude in its inhospitable mists and marshes, through a long line of mediaeval monks and nuns worshipping in their

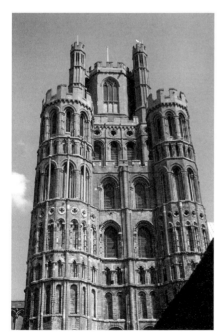

lonely priories and monasteries. Today there is a church tower in every village, and two of the finest cathedrals in the land.

The west front of Peterborough has been described as 'the most magnificent portico in Europe', with the figures of St Peter, St Paul, and St Andrew looking down from the gables over the three great arches. Ely with its mighty west tower soaring over 200ft into the sky, and its pinnacled, octagonal central lantern, dominates the surrounding town and the flat fens.

All in all a rather splendid double epitaph for some very humble beginnings.

The tower of Ely Cathedral.

CHAPTER FIVE

CAMBRIDGESHIRE CASTLES

There is one small problem in exploring castles in Cambridgeshire, which is that, practically speaking, there are none of them left. However, some of the sites remain, and the history behind them is fascinating. Wandering these grassed-over ditch lines and earthworks, and trying to guess at the meaning of all those tantalising dips and bumps, you have to use a little imagination.

There were two major phases of castle building in the county. The first of course was in the aftermath of 1066, when William the Conqueror divided up the lands of the shattered Saxons, and he and his Barons needed castles and strong points to consolidate their hold on the country. They either re-fortified the existing strategic points or constructed new ones.

This wave of castle building spread throughout England, and gave rise to new castles at Cambridge, Huntingdon, Bourn, Camps and Wisbech. They were standardised motte and bailey castles, the motte being a massive earth mound on which the timber home of the lord of the manor was built, and the bailey the earthworks topped with a stout palisade that enclosed the protected area at the base of the mound. For good measure the entire structure was usually surrounded by a moat. Later, stone walls and stone keeps began to replace the original timber.

River crossings were a favourite location, especially if they were overlooked by high ground. Where Castle Hill now stands in Cambridge there was an Iron Age settlement 2,000 years ago. Later the Romans built a fort here. When the Normans marched into the county they quickly refortified and built their own classic castle on the same site. It served as a military and administrative centre, royal castle and goal, and dominated the Cam Valley and the four roads that crossed the river.

In Huntingdon it was a similar story. The Romans may have built the first defensive earthworks to command the Great Ouse. Later the Danes had some sort of castle here, which Edward the Elder is recorded as having attacked and seized in the ninth century. The Normans again saw the potential of a commanding site over the river and refortified and rebuilt the Saxon castle.

At Wisbech the castle was built to combat the last stand of Hereward the Wake and his wild fenland rebels, and to control entry into the Great Ouse from the Wash. The arrow-straight Roman roads were in decline and the rivers had again become vital routes of transport and travel. To rule the still rebellious lands of the Saxons which the Normans had conquered it was necessary to control trade and traffic on both the roads and the waterways.

The pattern was repeated all over England during the years following the Conquest. However, the second wave of castle building was smaller and confined to Cambridgeshire. During the civil war that raged throughout the short reign of King Stephen, the rebel Baron Geoffrey de Mandeville threw out the monks of Ramsey Abbey and turned it into his own private fortress. Ramsey was then an almost impregnable island peninsular, guarded on three sides by impassable fens, and from there he raided and terrorised the towns and villages bordering the Fens. Stephen's response was to embark on a new mini wave of castle building to contain this threat. The major efforts here included Burwell and Rampton.

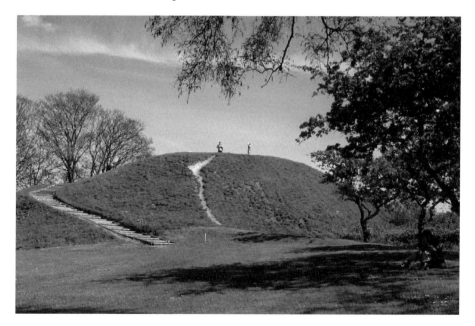

Castle Hill, Cambridge, fortified in turn by the Romans, the Normans and the Roundheads.

The crisis began with the death of King Henry I, who died leaving only his daughter, Matilda, as the heir to the throne of England. She was immediately usurped by her cousin Stephen and eighteen years of bitter civil war began between the barons and earls supporting the two opposing claimants to the throne. Baron Geoffrey was one of Stephen's key supporters, and it was Stephen who made him Earl of Essex. However, in the end Geoffrey turned against his benefactor and began to carve his own empire in the Fens.

To contain and surround Geoffrey's forces Stephen began the construction of a new chain of castles. Geoffrey saw the danger and attacked first. His forces besieged Burwell Castle before the work was finished. In the fighting he was struck by an arrow and withdrew mortally wounded. He died a few weeks later and his rebellion died with him. The work on the partially built castles at Burwell and Rampton was then abandoned. They had served their purpose and were no longer needed.

At Burwell the old castle site lies on the western side of St Mary's church. At ground level you can just make out the shape of the old grass bank earthworks, surrounding a tree-filled hollow with a small spring. From the church tower you can look out over Burwell itself, the small town dominated by its windmill, and, on the day that I saw it, sleeping in the sun. You can also look down on the peaceful green of the castle site, where children now play and their elders walk their dogs, and only the information boards tell of that desperate hour when Sir Geoffrey de Mandeville wielded sword and shield until that fateful arrow cut him down.

The castle site at Burwell from the tower of St Mary's church.

Rampton is a small, pleasant village with a tree-shaded green, thatched cottages and a white boxed village pump. The castle site, known as Giant's Hill, is almost hidden behind a high leafy hedge as you enter the village from the north. A wooden boardwalk crosses the moat to the old earthworks, in spring a glorious white mound of May blossom and waist-high white cow parsley. Again all is now peaceful, reeds fringe the still waters of the moat, and in the adjoining meadow cows doze sleepily in the long grass amid bright yellow buttercups.

I found more faint signs at Castle Camps down in the south-east corner of the county, separate from the present village but again close by an ancient Norman church. The line of the old moat and the earth bank of one of the old baileys were lined with trees. The humps and hollows in the grass field were the only other clues. The castle here was held by the earls of Oxford, although their main stronghold was at Hedingham in Essex. A village grew up around the castle, but was later abandoned, possibly due to the plague, and the castle fell into decline.

The ancient moat around Giant's Hill site at Rampton.

Castle Camps, the hedgerow marks the line of one of the old bailey earthworks and the moat.

At Bourn, William the Conqueror's sheriff built a castle which was later destroyed during another war of the barons in the reign of Henry III. Bourn Hall now occupies the site. Another vanished castle once stood at Cheveley, although this seems to have been no more than a crenellated home built in the twelfth century. There is a moat still there on private land, and tales of underground passages, which the local boys used to explore until their candles blew out.

Kimbolton also had a wooden motte and bailey castle during Norman times, although all that remains of it now is a small wooded hill in a field. A later castle, or possibly a fortified manor house, was re-sited at one end of the High Street around AD 1200. This version has been rebuilt many times, and survives today as Kimbolton School. In 1534, Katherine of Aragon was imprisoned here after her divorce from Henry VIII. She only lived for a few more months, but at least she did not lose her head.

Today Kimbolton is a charming small market town with a High Street packed with narrow-fronted old buildings, most of them ancient and timber framed but with Georgian facades. At the west end stands the church of St Andrew with its fourteenth-century tower and octagonal spire. At the east end the dominant feature is the magnificent seventeenth-century gatehouse to the castle, and behind it the massive foursquare structure of the present castle and school built around its mediaeval core.

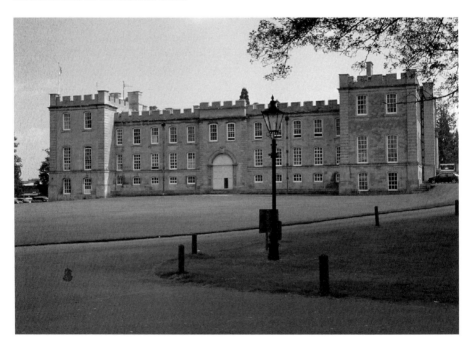

Kimbolton Castle is now Kimbolton School.

Kimbolton High Street.

Kimbolton Castle is a rare survivor, the passing centuries having erased most of those imposing mediaeval power bases. Huntingdon Castle was attacked and destroyed by Henry II in 1174. However, Huntingdon and Cambridge castles both had a flash in the pan revival during the seventeenth century when the king's Cavaliers were engaged in civil war with the Parliamentarian Roundheads. Oliver Cromwell refortified both sites with canon to control the still important vantage points over the Cam and the Great Ouse.

After that it was all over. The railway eventually ran through the site of the old bailey at Huntingdon, and now the A14 bypass slices by an otherwise peaceful public park. Castle Hill still remains at Cambridge, but the timber palisades have long since gone, and the later constructions of stone were mostly cannibalised to build the magnificent array of colleges, the modern glories of the city, that are now visible from the summit.

At Wisbech the circular shape of the castle moat can still be seen in the splendid red-brick curve of the Georgian Crescent. Otherwise only the name and the memories remain. All the rest – the vanished power struggles, the mediaeval mix of harsh reality, pride, pomp and glory – we have to recreate for ourselves from a series of overgrown earthworks, and our own imagination.

CHAPTER SIX

THE UPPER
NENE VALLEY

The River Nene is one of the most beautiful rivers in England and the Upper Nene Valley, where it winds gently through rolling green hills into Cambridgeshire, has to be one of the most eye-pleasing stretches of all. Here the river slowly loops around the sleepy village of Stibbington, double-dipping after Water Newton and then making another high turn around the Ferry Meadows Country Park before gliding gracefully into the heart of the city of Peterborough.

The whole valley was well known to the Romans who settled here and established one of their major pottery-making industries. Stibbington was originally part of the Roman town of Durobrivae and there are still traces of the old Roman kilns and a pottery workshop. It lies close to the Great North Road where once the Roman legions would have marched under their proud eagle standards on their way to fight the Picts and the Scots. They were only the first of many travellers to pass this way and later this was an important stop for the eighteenth-century mail coaches. The Haycock Hotel was a major coaching inn where post horses were stabled and parts of the building can be dated back to the thirteenth century.

The main settlement of Durobrivae seems to have been a few miles further down the river at Water Newton. The name Durobrivae means 'the fort at the bridge' and there was a small 5-acre fort erected here to house the Roman garrison guarding the river crossing. Aerial photographs have identified the outlines of the ramparts, gateways and defensive ditches. More pottery kilns have been located where calcite-gritted cookery pots were produced. Clay for the pots and wood for the fires would have been brought in by riverboat and the finished pots despatched up and down the river.

The Roman links also remain in the parish church which stands close to the south bank of the river. The church is dedicated to St Remigius who was the Roman Bishop of Rhiems.

Durobrivae was one of the most flourishing Roman towns in England and one of the earliest collections of Christian liturgical treasures from the whole of the Roman Empire was discovered while ploughing a field in 1975. The hoard consisted of beautifully engraved and embossed plates and cups and bowls, twenty-seven of silver and one of gold.

The Water Newton treasures are now housed in the British Museum in London, but Peterborough Museum does have a replica collection.

Across the river on the north side is Castor, another charming little village with an extensive Roman heritage (Castor being named after Castra, meaning a Roman camp). The whole area is littered with traces of Roman villas and estates and the thriving pottery enterprise, all pointing to the fact that many of the Romans who settled here were comfortable and wealthy. One villa site is so large that archaeologists at first though they were dealing with a separate small town.

The pottery made here was the distinctive Castor Ware and many of the pieces were decorated with hunting scenes on a coloured glaze. A splendid Praetorium, the home and administration centre for the Roman governor or magistrate, was once built on the hill where the church now stands. Roman baths, mosaics and burials have all been unearthed in the area.

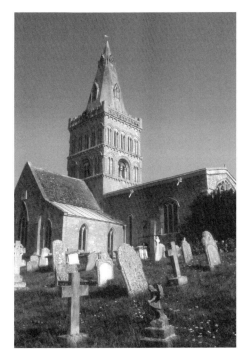

After the Romans had departed, the Saxon princess Kyneburgha and her sister founded a nunnery on the Praetorium site. The sisters were the daughters of Pendra, the Saxon King of Mercia, one of the most powerful of the Anglo-Saxon kingdoms which eventually filled the vacuum left by the withdrawal of the Roman Empire. The Norman church that was later founded in the twelfth century was dedicated to St Kyneburgha, and as the shrine of the saint still attracts many pilgrims and visitors. It is a Grade I listed building with a mixture of Roman, Saxon and Norman stonework and some notable mediaeval wall paintings.

Castor church, dedicated to St Kyneburgha, a Saxon nun who founded a nunnery here.

Archaeological excavations were carried out in the church grounds in the nineteenth century and a more recent dig by the BBC *Time Team* fronted by Tony Robinson has uncovered more of the large Roman villa that stood here in the second and third centuries. Around 3ft down in the churchyard is a large mosaic floor, just below a layer of seventeenth-century bones. It seems that the old grave-diggers were forced to bury the bodies in shallow graves on this site because they could not dig through the ancient Roman floor.

Down the valley from Castor the Nene makes its high loop around the Ferry Meadows Country Park with its inner loop of connecting lakes and islands. The huge amounts of gravel needed for the construction of the new town of Peterborough were excavated here and the builders and planners were far-sighted enough to see that the ugly gravel pits they were creating could be flooded and transformed to make a series of lovely lakes.

Every kind of water sport is catered for, from dinghy sailing and water-boarding to slow rowing boats or pedal boats. There are quiet spots for angling and pleasure beaches and playgrounds for the children. Other activities are also provided including footpaths and walks, golf courses and a woodland nature reserve filled with butterflies and birds.

Cows graze here and rabbits romp freely. There is pond life and dragonflies and large flocks of geese. Horses and riders pass in their slightly haughty way, riders straight backed and horses with their heads up. For those who want a

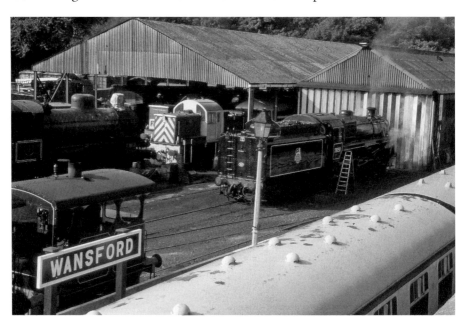

Wansford Railway Station.

child's run at the real thing there is even a miniature railway with a pint-sized steam train running from the visitors' centre and alongside the lakes.

The real thing of course is the Nene Valley Railway, where the tracks cut an arrow-straight course across the twists and bends of the river. As the Industrial Age flowered, the line became part of the vital cross-country network which linked East Anglia to the busy Midlands. It originally opened in 1845 despite some fears that the vibrations of the passing trains would undermine the foundations of Peterborough Cathedral. The mainline trains ran for over 100 years until the track was finally closed by British Railways in 1966.

However, this picturesque section of the line was not to remain closed for long. An enthusiastic group of volunteers were dedicated to its preservation and in 1977 the Nene Valley Railway was reopened. The restored section of the line runs for a mere 15 miles from Peterborough to Wansford but massive black steam engines pull the carriages, hissing mightily and puffing smoke, and the journey is pure nostalgia.

The station yard at Wansford is the new line HQ and the yards here contain a wonderful collection of English and Continental locomotives, carriages, goods wagons and other rolling stock. A 67ft turntable is restored to working order. All along the line stations and signal boxes have been restored and everything is as it was during the glorious age of steam. The museum at Wansford is full of old posters and memorabilia.

Even for adults there is pleasure in watching these steel dinosaurs from a lost age chugging majestically through the beautiful scenery, but for the kids the catering goes over the top. There are Teddy Bear trips, Santa Specials, and of course themed events around the little blue engine with the black nose and smiley face that is Thomas the Tank Engine.

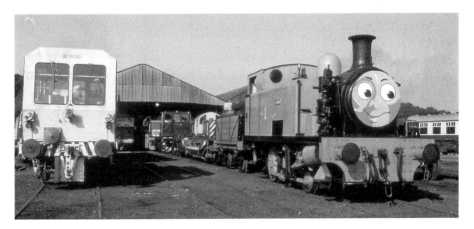

Thomas the Tank Engine.

All the stations – Wansford, Ferry Meadows and Orton Mere – will let you off onto riverside picnic sites and lovely walks where the countryside and its wildlife are to be enjoyed, and the end stop at Peterborough is only a ten-minute stroll into the heart of the historic city centre. The city is built around its magnificent cathedral, and from the massive arched gateway into the cathedral precincts there is also a clear view back to the sixteenth-century guildhall.

The archaeological excavations at nearby Flag Fen tell us that the whole of the Nene Valley was farmed and occupied way back in the Bronze Age. Iron replaced bronze as a harder and more durable metal and the populations grew, probably becoming more tribal than the smaller family communities of the earlier ancient Britons. Then the Romans invaded and the legions marched into the Nene Valley. Durobrivae was their chosen centre for their regional and administrative capital and it was not until the Romans had departed that Peterborough began to develop. In 655 the Saxon King Peada of Mercia founded the monastery that was to become the modern cathedral and the town grew slowly around it.

Peada's monastery was destroyed 200 years later when the rampaging Danes ransacked the town. Another monastery was built as part of a Benedictine abbey but in 1116 that too was razed to the ground by a disastrous fire. Religious faith was strong and dominant in those days and the devotion of the monks was stubborn and durable. Less than two years passed before the abbot and his patient flock began rebuilding again, and from this third great effort the present cathedral began to take shape.

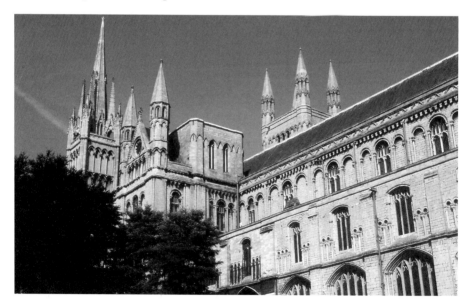

Peterborough Cathedral.

The next great crisis for the abbey came in the sixteenth century during the reign of Henry VIII. Henry's struggle to sire a son and heir, his string of wives, some divorced and some beheaded, his clash with Rome and his Dissolution of the Monasteries is one of the key periods of English history. One wife who refused him a divorce was Katherine of Aragon. Henry ordered her to be kept a prisoner in Kimbolton Castle and there she was incarcerated until she died. She was buried in the abbey church at Peterborough and her tomb is still there in the north aisle of the cathedral, draped with the flags of both England and Spain.

A few years later Henry shut down Peterborough Abbey and confiscated all its lands and properties in the great wave of closures that changed the face of England and curtailed the power of the Church for ever. However, eighteen months later Henry had a change of heart and promoted the old abbot into a newly created bishopric with the old abbey church as his new cathedral. At this point in time Peterborough became a city.

Perhaps there was some love left for Katherine of Aragon and Henry decided that he did not want her tomb violated or unattended. Or perhaps Henry's motives were more complex. By a cruel twist of fate Katherine's successor, the ill-fated Anne Boleyn, was delivered of a stillborn child on the same day that Katherine had been buried. In these superstitious times this was perhaps enough to cause even the most arrogant of kings to waver in his resolve.

Mary, Queen of Scots was also buried in Peterborough after her execution at Fotheringhay Castle in 1587. James I ordered the tomb of his mother to be moved to Westminster in 1612, but for a brief period the remains of two English queens had rested in Peterborough Cathedral.

The English Civil War brought more damage to the cathedral, perpetrated by Oliver Cromwell's contemptuous Roundheads. They smashed up the interior, destroying all the stained-glass windows, the high altar and the choir stalls. The central tower had been restructured in the fourteenth century and in the 1880s it again had to be rebuilt. After this the entire central and eastern area of the great church were refurbished with new hand-carved choir stalls and a new high altar.

The lovely old guildhall which faces the cathedral was built in 1670. It has a single first-floor room with mullioned windows, topped by a triangular clock gable. It is built over an open courtyard and supported by massive mediaeval stone arches and pillars. It makes a grand venue for a semi-open-air event and the most memorable of these were the town crier competitions, which for a brief period around the turn of the second millennium were an annual event.

In 2004 the town criers made a magnificent spectacle in a perfect setting as they congregated beneath the flag-draped colonnades. Eighteen town criers and their consorts, in mediaeval costumes of scarlet and gold, royal blue and Lincoln

green, all frock coats and breeches and polished buckles, awash with lace sleeves and collars, topped with plumed hats, and all of them brandishing their gleaming gold brass bells.

They had met earlier in the mayor's parlour at the Town Hall, for a briefing of the day's events, and to draw their positions in the two rounds of the crying contest. Then they had marched in procession, with all due pomp and ceremony, from the Town Hall to Cathedral Square. They were led by the Mayor of Peterborough, in robes of red and gold, and by the Host Crier, Peterborough's Pearl Capewell, in a royal blue gown and a gold-trimmed black cocked hat with a flamboyant white feather. Just the kind of festive civic occasion for which the guildhall was made.

Behind the guildhall stands the fifteenth-century church of St John the Baptist which completes the triumvirate of fine mediaeval buildings which form the historic heart of the old city.

Peterborough expanded with the coming of the railways. As a major junction with first-class links to the rest of the country it was perfectly positioned to attract national leaders in manufacturing and engineering. Diesel engines were made here and brick works proliferated. After the Second World War the elevation of Peterborough's status as a government designated New Town gave the economy another boost. Today Peterborough is thriving and still looking forward.

Despite the surrounding industry, Peterborough retains its charm. The waterfront is an area of willow-lined walks where you can relax on the

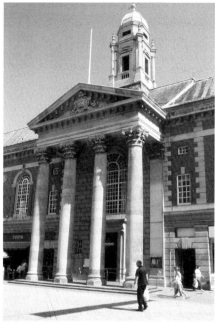

Far left: Peterborough Guildhall

Left: Peterborough Town Hall

embankment and watch the motor cruisers and the swans pass under the Town Bridge. The river, as everywhere along the Upper Nene Valley, is always a joy to watch. The city's flower-filled gardens and parks provide more recreation and relaxation facilities. Shoppers are spoiled by the massive modern Queensway complex, a modern cathedral of glass and steel with its arcades filled with top-quality stores.

Nearby is the East of England showground where top agricultural shows, the National Shire Horse Show and an annual Truckfest are held. There are two main entertainment venues in the city: the Key Theatre overlooking the River Embankment and the Broadway film and theatre complex in the city centre.

For the culture vultures who haven't yet had enough heritage within the historic centre there is still the Longthorpe Tower situated in the small village of Longthorpe which has now been swallowed up as part of the expanding residential area of Peterborough. The three-storey fourteenth-century tower was part of a fortified manor house and is now maintained by English Heritage. It contains the best surviving examples of mediaeval wall paintings in the whole of Northern Europe, which have been described as a spiritual encyclopaedia of worldly and religious subjects, including the *Wheel of Life*, the *Nativity* and *King David*.

Peterborough and the beautifully scenic Upper Nene Valley have it all.

CHAPTER SEVEN

THE TIDAL NENE

After leaving Peterborough the Nene flows placidly east toward the sea. Beside the little town of Whittlesey it encounters the great steel barricades of the Dog in a Doublet lock where the advance of the lower river tides are checked. From here the river is tidal all the way to the Wash.

Whittlesey, like most Cambridgeshire towns, was once an island surrounded by the great watery marshes of the Fens. The town appears in Domesday Book as Wittisei, which translates as Whittle's Island, so the original Whittle was probably a Saxon farmer who had a homestead here.

Human habitation in the area goes back much, much farther. Whittlesey is only a few miles north of Britain's premier Bronze Age Heritage Centre at Flag Fen. Here archaeologists have uncovered and recreated the remains of an extensive prehistoric settlement which can be traced back over 3,000 years.

Whittlesey's two main churches are St Andrews and St Mary's and until the time of the Dissolution, despite their proximity to Peterborough, the two parishes were controlled by the great abbeys of Thorney and Ely. The glorious spire of St Mary's lifts high above the town, supported by elegant flying buttresses on top of the massive church tower. It is one of the tallest church spires in Cambridgeshire and a highly visible landmark which can be seen for many miles across the flat Fenlands.

St Mary's stands just a little bit back from the Market Place. St Andrews is further out on the Ramsey Road and although smaller and not quite so spectacular it is very beautiful inside with a light and airy atmosphere. The church with its crenellated roof and tower and sturdy porch is constructed of sun-mellowed ochre sandstone. In mid-summer, butterflies and small birds can be seen flitting among the old, weathered gravestones.

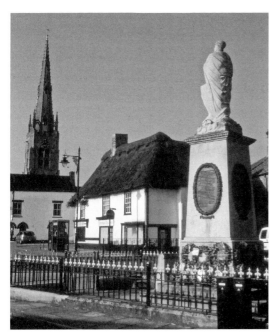

Whittlesey memorial statue and market square with spire of St Mary's.

The centre of Whittlesey is the Market Place which is dominated by the late seventeenth-century Buttercross – a square, open space on pillars with a steep pitched roof. Once all the trade and bustle of a rich mediaeval agricultural market town was played out in its shade and shadow. The scene is calmer now but there is still a regular Friday market and once a month a traditional country auction. The Buttercross is now sadly reduced to the status of a bus stop but its presence is still a reminder of that more hectic past.

Just up Market Street is the old Town Hall which dates back to the nineteenth century. This four-squared building with high arched doorways and windows has a chequered history. It was once used to house the town's horse-drawn fire engine. It is now the town museum and among the rich tapestry of archaeological and social history exhibits here you can still find a mammoth's tusk and the bones of a woolly rhinoceros which roamed the area 50,000 years ago.

Among the personality displays you can find the story of General Sir Harry Smith, who ranks as Whittlesey's most famous son. He also has a monument to his honour in St Mary's church.

Sir Harry had a very successful military career during the time of the Napoleonic and the Sikh wars. In 1848, at Aliwal near the North West Frontier of India, Sir Harry had command of an army of 12,000 British and Bengali troops with thirty cannon to face the Sikh army of the Punjab with 30,000 men and sixty-seven cannon. A heroic charge by the 16th Queen's Lancers broke the Sikh defensive square and won the battle.

The Wittlesey boy went on to make his mark on two continents when he later became the Governor of Cape Colony in South Africa. There he founded and named the town of Aliwal North to commemorate his victory over the Sikhs. The South African town of Ladysmith, made famous by its siege and relief in the Boer War, was named after Juana Maria de los Dolores de Leon, who was Sir Harry Smith's Spanish wife.

Today Wittlesey is best known for the annual Straw Bear Festival when hundreds of morris dancers and musicians take to the streets to parade the 'Straw Bear' through the town. The long, colourful and exuberant procession makes frequent stops for music and dancing with a variety of morris, molly, clog and sword dances. Jingling bells, thwacking sticks, twirling handkerchiefs, tattered jackets and flowered headdresses are all accompanied by a cheerful swirl of accordions, drums, flutes and violins. Clowns and mummers add to the general free-for-all of merriment and entertainment.

Despite being held in the sometimes bitter cold of early January the event draws crowds of thousands. Originally the Straw Bear appeared on the Tuesday following Plough Monday when one of the plough boys would be covered in twists of straw which would be bound tightly around his legs and arms and body. Sticks would form the basis of the bear shape, a frame was mounted on his shoulders so that his head and face could also be totally obscured and he probably wore a straw tail. He was led around on a chain and his keeper carried a collection box.

Left: Straw Bears at the Whittlesey Straw Bear Festival.

Below: The Dog in a Doublet lock.

It seems that the police eventually frowned upon the practice as a form of begging and the tradition came to a halt in 1909. There was a break of seventy-nine years and then this unique fenland custom was revived again by the Whittlesey Society in 1980. It was soon noticed by the rising tide of morris sides which flocked to support what has now become a two-day festival on the weekend preceding the traditional Plough Monday.

Each year the Straw Bear costume is ritually burned in a lunchtime ceremony on the Sunday. The new bear is always fashioned from the best straw from the following harvest.

The pleasant little Briggate River which flows past the Manor Fields on the south side of the town is part of the Nene–Ouse Navigation link which puts Whittlesey firmly on the Fenland waterways map. It will take us back to the main flow of the River Nene and the Dog in a Doublet lock.

The lock is named after the Dog in a Doublet pub which stands beside it on the north bank. Sadly the pub is now closed but the massive sluice gates still form a barrier to the tides. The river flows ever eastward through the flat fens and passes through tiny village of Guyhirn.

The new road bridge at Guyhirn marks an important junction of roads and river. The A141 coming up from March and Chatteris to the south meets the A47 coming from Peterborough to the east and the two become one as they head west into Wisbech. This is also the place where Morton's Leam, one of the many cuts dug to help drain the Fens, ends its 12-mile parallel flow and joins the Nene. Another set of giant sluice gates control the point where the fresh and salt waters meet.

The narrow strip of lowland between the two rivers is prone to flooding and has become an important wildfowl site. Moreton's Leam is rich in freshwater fish and has become a popular spot for anglers.

Guyhirn is a thin line of houses, strung out along the road and river. The village seems to have had an on-off religious history. The current church of St Mary Magdalene is a charming neo-Gothic style building shaded in a small copse of trees. When its foundations were dug in 1877 some of the stones of an earlier mediaeval Gothic church were found on the site. It is estimated that more than 100 years had elapsed between the fall of the old church and the erection of the new.

In the meantime a small chapel had been built during the time of Oliver Cromwell but was never consecrated. This was probably because the churches were then being forced by political and royal whims to swing back and forth between Catholicism and the new Protestantism. This chapel, sometimes known as the Guyhirn Old Chapel, or the Guyhirn Puritan Chapel, still remains as a Chapel of Ease in the small cemetery.

After passing Guyhirn, the Nene flows side by side with the A47 until it reaches the town and port of Wisbech. In mediaeval times Wisbech was an important trading centre. It was then a port on the River Ouse but the old estuary silted up and the Ouse was diverted to the sea at King's Lynn in Norfolk. However, when the present artificial course of the River Nene was constructed from the Peterborough to the Wash, Wisbech thrived again. The town grew rich on exports of corn and imports of coal from the North and timber from the Baltic. The drained marshes surrounded it with rich agricultural farmlands which added to its prosperity. Wisbech today is an inland port, still 12 miles from the Wash and the sea, and the only port in Cambridgeshire.

In the heart of Wisbech the broad flow of the Nene is spanned by two bridges, the Freedom Bridge and the Town Bridge. From the Town Bridge there is a grand view up the river between the Brinks. The North Brink and the South Brink are streets of elegant Georgian houses which face each other over the water. These were once the homes of wealthy merchants, and the men who owned land, ships or warehouses. The perfectly proportioned Peckover House is the finest of them all. Its yellow and red-brick, three-storey front overlooks the river with its splendid Victorian gardens behind. It is a house which has been described as the perfect Englishman's retreat.

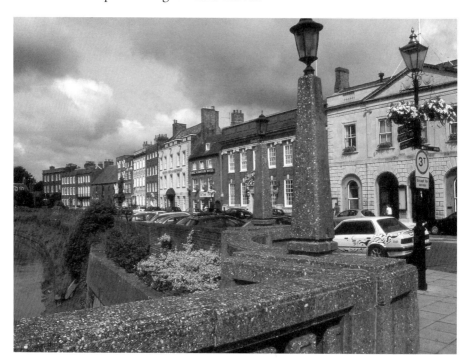

Wisbech from the town centre bridge.

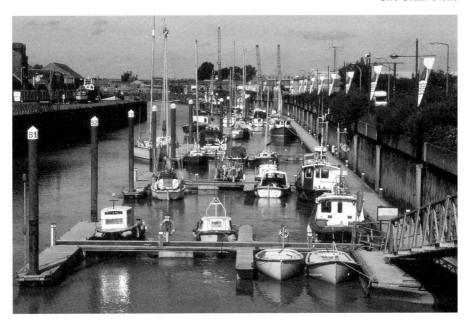

The yacht harbour at Wisbech.

At the far end of the North Brink stands the classic Georgian Elgood's Brewery which has dominated the river for over 200 years. The first brew was made in 1878 and today visitors can tour the premises to view the entire brewing process using the original copper vessels, and finish up by sampling a range of traditional ales. The brewery also has 4 acres of gardens including a small lake, a rockery and water features. On a warm day, surrounded by flowers and herbaceous borders, it is the ideal place in which to relax and wander after a cool beer.

Walk down North Quay to the Freedom Bridge and here you can look downriver over the busy yacht harbour, packed with small craft of every description. This is still a busy commercial port, but the leisure industry does seem to be taking over. The new facilities here provide pontoons with berths for seventy-five sailing boats or motor cruisers.

If you want more Georgian splendour, look for The Crescent. These two delightful curves of Georgian town houses were built to follow the contours of the old castle moat and walls. William the Conqueror built a castle here to combat the forces of Hereward the Wake, the Saxon nobleman who led a last defiant rebellion against the new Norman overlords from the watery wilderness of the Fens.

The castle is long gone now, another ghost castle like all the castles of Cambridgeshire. It was replaced by a Bishop's Palace in 1578, and then later in the seventeenth century by a fine mansion house built for Oliver Cromwell's Secretary of State. The present regency villa which occupies the site was built in 1816.

Wisbech, The Crescent and church.

Behind The Crescent and at the end of the High Street is the Market Place, a paved and landscaped pedestrian zone where a traditional market is held twice weekly. There is an old Market Place on the far side of the river which is where the market was held until the thirteenth century. Then the new market grew under the shadow and protection of the Norman Castle and gradually the old market declined.

The twelfth-century church of St Peter and St Paul with its double nave and sixteenth-century tower is close by The Crescent and the Market Place. The church and its sumptuous rose gardens are the setting for the annual Rose Fair.

The fair began almost fifty years ago when rose buds were sold in the church gardens to raise funds. On the festival weekend in mid-summer white tent stalls and throngs of people fill the grounds which are a riot of red roses. The interior of the church is filled with glorious flower tableaus and arrangements all beautifully lit by the fragmented sunlight streaming through the Victorian stained-glass windows.

Three other churches, the Baptist church, the United Reform church and the Trinity Methodist church all hold their flower festivals at the same time. Delicious fen strawberries are served with cream and the highlight is a procession of flower bedecked floats which winds through the town on the Sunday.

In addition to William the Conqueror and Hereward the Wake Wisbech has many other historical connections. King John stopped here shortly before he

lost his crown jewels and his treasure train trying to race the flood tides across the Wash. Octavia Hill, the co-founder of the National Trust and one of the pioneers of social housing reform, was born here, and her birthplace on the South Brink is now a museum commemorating her life and work.

Another great humanist, Thomas Clarkson, who dedicated his life to a tireless campaign for the abolition of the slave trade, was also born here. He was the son of the headmaster at the grammar school. A plaque has been laid in his honour in Westminster Abbey and here in Wisbech his memorial statue, under an impressive spire canopy, stands overlooking the Town Bridge.

From Wisbech the Nene has only a few more miles to flow before it passes from Cambridgeshire into Lincolnshire to make its entry into the shallow floodwaters of the Wash.

CHAPTER EIGHT

THE HEART
OF THE FENS

The Middle Level comprises that peaceful network of waterways at the heart of the Cambridgeshire fens. The Nene–Ouse Navigation Link allows houseboats and motor cruisers to leave the Nene at Whittlesey and wend their way to the busy Fen town of March. From there the link continues through the smaller but picturesque villages of Outwell and Upwell and on to Downham Market in Norfolk to meet up with the Great Ouse, which will take you back into Cambridgeshire again. All of it under a great vault of open blue skies with little more than church and windmill towers and that magnificent lantern of Ely Cathedral, the great 'Ship of the Fens', to break up the flat skylines.

March is a charming little riverside town with 1,000 years of history. It sits on either side of the old River Nene and was initially just one of those small islands of uplifted land in the watery vastness of the Fens. Its inhabitants would have made their living from fishing and fowling and trading along the interlinked maze of creeks and rivers.

The name comes from the Anglo-Saxon word for a frontier or border, for March was a border town on the wild frontier between the ancient Saxon kingdoms of Middle and East Anglia. There was always an important ford here, on the way between the major towns of Wisbech and Ely, and when the Romans came it was on the path of their new Roman Road, the Fen Causeway. As the Fens were gradually drained March grew and prospered as a religious and trading centre. In the Middle Ages it was a busy small town and a minor inland port. In 1556 it was home to eight boats trading in grain and coal and most other goods were shipped in by barges.

The river provided the town with its flow of goods and commerce and the stimulus to faith was provided by the splendid church that is dedicated to St Wendreda. She was one of three Saxon princesses who lived in the

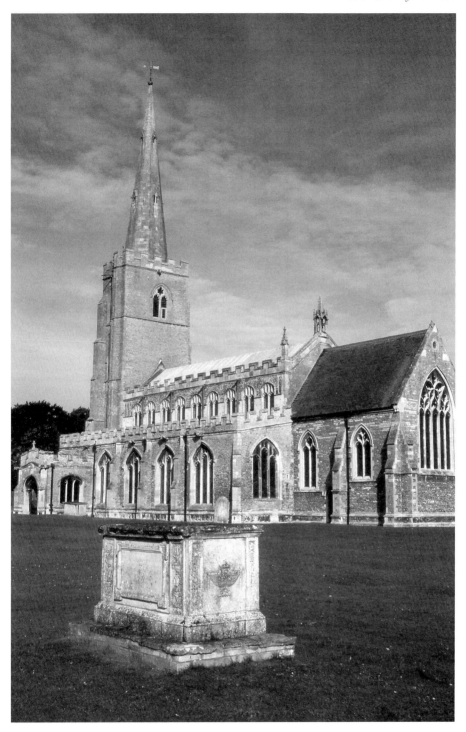

March, St Wendreda's church.

seventh century, the daughters of King Anna of East Anglia who was killed in 654 in a battle against the kingdom of Mercia led by King Penda. Anna was one of the first Saxon kings to become a Christian and his daughters bravely continued to champion his faith. All of them became saints: Ethelreda became the abbess of Ely Cathedral; Sexburgha became abbess of Minster in Sheppey; Wendreda was renowned for her Christian good work and came to the area around March where she cared for the poor. When she died her body was embalmed and became a focus for pilgrimage and veneration.

Wendreda's mummified body was held in such high esteem that Edmund Ironside had it carried before his army when he went to battle with the Danish King Canute in 1016. The English lost and the Danes captured the relics of the dead saint. However, Canute had already converted to Christianity and he already had a healthy respect for English saints.

Canute had seen his father collapse and die on an earlier raid into East Anglia. While threatening the great abbey at Bury St Edmunds his father had screamed that the ghost of St Edmund was coming for him on a white horse with a silver lance. His death was probably caused by a heart attack but his last screams were heard and heeded by his cautious son. Canute had St Wendreda's bones carefully returned to Canterbury and he also paid due homage at the tomb of St Edmund soon after he was crowned King of England.

It was not until the fourteenth century that St Wendreda's remains were eventually returned to March, inspiring the construction of what has to be one of the most beautiful churches in the whole of the Fens. The church is a Gothic masterpiece with a battlemented tower topped by a graceful spire that soars up into the heavens. Inside is a magnificent double hammer-beam oak roof adorned with carvings of the twelve apostles and 120 angels playing musical instruments. The poet Laureate John Betjeman has famously said that the church was 'worth cycling forty miles in a head wind to see'.

March is divided into four ecclesiastical parishes and so is well blessed with churches. The others are dedicated to St Peter, St Mary, Mary Magdalene and St John. There is also a Roman Catholic church and a Centenary Baptist chapel.

The river traffic was usurped by the coming of the railway and for a time the sprawl of the Whitemoor marshalling yards was the largest in England. They were built in the 1920s and '30s but the town's reign as a major rail centre was short-lived. By the 1960s they were beginning to be phased out and now the Whitemoore prison occupies part of the site.

To explore the town today you can follow two well-marked routes, the Town Trail and the Riverside Trail. They are divided by the handsome one-arch stone bridge that spans the River Nene. The river will be lined with colourful houseboats and clean white pleasure cruisers, with never a working barge in sight.

The Town Trail follows the High Street south from the river. It begins at the March Museum which was built as a girls' grammar school in 1851 and continues past Trinity church, which has an impressive frontage consisting of a massive, cross-topped gable over double doorways and two slender minarets.

A little further on is the ancient Stone Cross, on what may have been the site of the Old Saxon market. It was also used as a Preacher's Cross and is said to be the first site chosen for St Wendreda's church. Legend says that many attempts were made to build the church here, but every morning the returning workmen found their previous day's labour destroyed. The saint obviously had her own choice of location which is at the far end of the Town Trail. On the way you will pass a beautiful block of Victorian almshouses which are all red brick, high gables and high chimneys.

After visiting St Wendreda's church at the far end of the town the trail brings you back on the opposite side of the High Street. The highlights of the return walk are the imposing Italianate block of the old courthouse, all white brick and arched doorways and windows, and the splendid Corn Exchange overlooking the Market Place. A classic piece of Renaissance architecture in more red brick, the Corn Exchange has a 110ft-high tower topped by a jubilee clock and a statue of Britannia. It became the Town Hall in the 1970s but is now used as a community venue and arts centre.

Continue past the Market Place and you have reached the river and the bridge that will take you across and straight on to the riverside walk on the far side. Apart from the river and the moored and passing houseboats and pleasure traffic, the highlights here are the war memorial, the fountain and the white-stone Jacobean frontage of Bank House.

The fountain is a cast-iron filigree cupola supported on archways above eight slender pillars. It commemorates the coronation of King George V and was originally a drinking fountain flanked by horse and dog troughs. It is smartly painted in silver and gold and forms an ornate and elegant adornment to a very pretty little town.

March, the Memorial Fountain.

Past residents of note include the engineer driver Benjamin Gimbert who won the George Cross for saving an ammunition train from the fire of the Soham Rail Disaster. The wagon behind the engine had caught fire. Gimbert's fireman uncoupled the rest of the train and then rejoined his driver on the footplate as Gimbert drove the engine and the burning wagon clear of Soham station and the rest of the ammunition train. When the wagon exploded fireman James Nightall was killed and Gimbert severely wounded.

Billy Barker was also a resident of March, a waterman who saw no future in the Fens with the coming of the railways and emigrated to America during the 1840s. He tried his luck prospecting for gold in the California Gold Rush where he was unsuccessful but undaunted. When the gold ran out in California Billy moved with a group of fellow miners up to Canada and British Columbia where his party discovered gold in Williams Creek. Billy Barker grew rich and founded the town of Barkersville on the site.

Go back up the river toward Whittlesey and at Floods Ferry it is possible to divert down another branch of the old River Nene to Ramsey. The focus here was always the great abbey and after the devastating impact of the Dissolution the town, which had grown up around the abbey precincts, went into decline. Then the draining of the Fens surrounded Ramsey with rich farmlands of black soil which led to its regeneration.

The most impressive street in Ramsey is the Great Whyte, with a width of 80ft it is almost twice as wide as any ordinary street. In mediaeval times it was Bury Brook, an open waterway navigable by small boats. In 1852 the brook was channelled into a single underground tunnel. When the floods came this proved to be inadequate so two more culverts had to be added.

Enhancing the Great Whyte is a handsome, black-painted cast-iron clock tower. The clock face is framed in four uplifted lanterns with leaf decorations on the curved support arms. It was erected in 1888 to the Right Hon. Edward Fellowes who became the first Baron of Ramsey.

Ramsey, the clock tower.

Two parallel streets, the Little Whyte and the High Street, lead off the bottom end of the Great Whyte toward the Abbey Green. At the head of the green stand the almshouses built for twelve poor women in 1839 using some of the stone cannibalised from the ruins of the abbey. More of the stone went into the building of Trinity College in Cambridge and the towers of several churches. The Cromwells had acquired the abbey after the Dissolution and sold off most of its usable building materials.

Beside the almshouses is a former church school built in yellow brick and at the top right-hand corner of the green stands the impressive grey tower of the church of St Thomas à Becket. More stone from the abbey was used in the building of the church.

At the bottom end of the green is one of the two surviving fragments of the abbey, the broken silhouette of the once magnificent gatehouse. The gatehouse is now the entrance to the grounds of the Ramsey Abbey School. After they had demolished the old abbey the Cromwells built a new manor house, saving only the thirteenth-century Lady chapel which was incorporated into the new building. The house has undergone many changes to become the Abbey School.

Ramsey is well blessed with a series of leafy greens, all shaded by overhanging elms and chestnuts. Church Green lies beyond the church and has the added attraction of a placid, reed-fringed pond. Here you will also find the war memorial, a tall octagonal column of Portland stone with a bold bronze statue of St George slaying the dragon on top.

Like March to the north, Ramsey expanded with the coming of the railways in the first half of the nineteenth century. Two separate branch lines were built by different companies and each had its own railway station at opposite ends of the town. Plans to link the rival stations never materialised and when the railways were nationalized in 1949 both passenger lines were closed to traffic. As swiftly as it had arrived, the glorious heyday of steam engines and rail travel was gone. However, Ramsey now has excellent road links and continues to thrive.

Chatteris is the third little market town here in the heartland of the Fens. It is not quite on the river network but is closely passed by the straight cut of Vermuyden's Forty Foot Drain and linked by road and the Black Fen Waterway Trail to both March and Ely. The name Chatteris is derived from the Anglo-Saxon *Cateric*, which means a wood on the river.

Initially there was a church here, founded, so the legend says, by Huna, the chaplain of St Etheldreda, who became a hermit on Honey Hill after the death of his mistress. This first church was probably swept away by the marauding Danes on one of their many forays of burning and pillaging. Later, around AD 980, in the usual fenland tradition, Aelfan the Countess of East Angles

founded a Benedictine abbey here, the abbey of St Mary. The history of the Fens tends to repeat itself wherever there was a major settlement.

The parish church dedicated to St Peter and St Paul was given by Bishop Nigel of Ely in 1162. Both the church and the abbey were badly damaged in the great fire at the beginning of the fourteenth century. The fire also burned down most of the town. The church was rebuilt and re-consecrated. The remains of the abbey survived until the Dissolution but then there were only eleven nuns to be evicted. The Chatteris abbey was never as rich or powerful as many of its contemporaries because it had no royal patronage and few land tithes to collect.

Chatteris today has another guide-marked Town Trail which takes in a range of interesting Georgian and Victorian architecture and buildings. It begins at the church where there is a splendid view over the Fens from the top of the tower. It is one of the few places where you can see the distant towers of two cathedrals, Ely to the south east and Peterborough to the north-west.

The church also contains some beautiful stained-glass windows. The east window of the chancel is a memorial to the men of Chatteris who died in the First World War. In the side chapel there are three stained-glass windows, depicting the crucifixion and the resurrection, and another memorial to a former choirboy, William George Burdett Clare, who was awarded the Victoria Cross in 1917.

Clare was a stretcher bearer at the Battle of Cambrai in France. He continuously collected wounded men, giving them first aid and then conducting them to the relative safety of a dressing station on a bloody battlefield raked with machine-gun fire and blasted by shells. Eventually a shell explosion killed him and his VC decoration for conspicuous bravery and devotion to duty was a posthumous award.

The Town Trail takes you on past the Palace Ballroom. Originally it was the town corn exchange but the passage of time has seen it become Picture Palace cinema, then the ballroom and now a club and restaurant.

Chatteris church.

1. The Fenlands of Cambridgeshire.

2. The Backs of the colleges are glorious in spring.

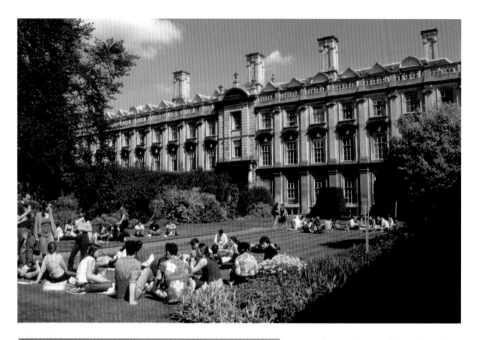

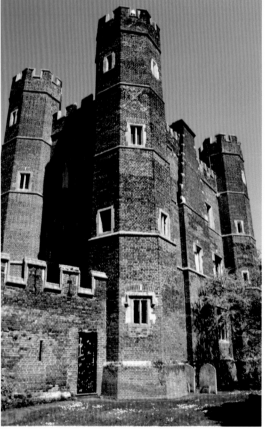

3. Students relax on the Backs of the colleges.

4. Buckden Towers.

5. The river at St Ives.

6. The waterfront at Ely.

7. Re-enacting the Battle of Naseby, the decisive battle of the English Civil War.

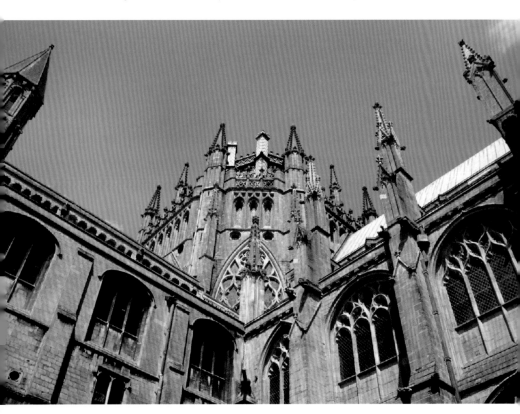

8. The magnificent octagonal lantern of Ely Cathedral.

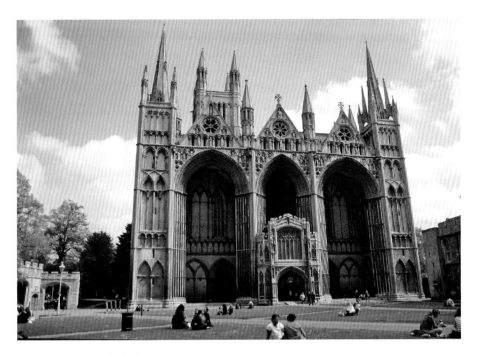

9. Peterborough Cathedral.

10. Bridge over the Rive Nene.

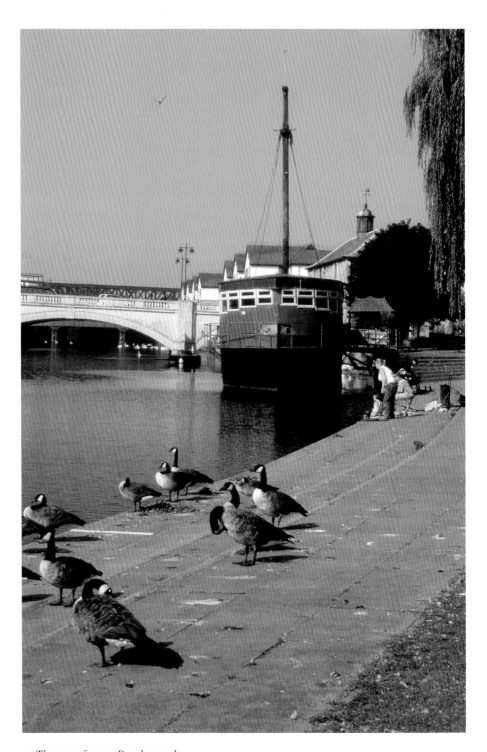

11. The waterfront at Peterborough.

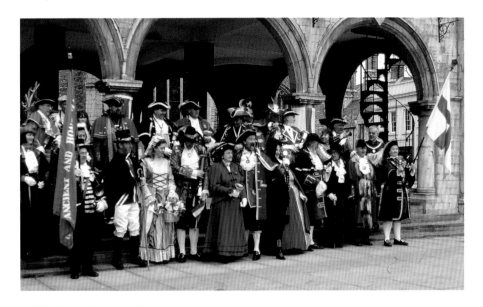

12. Peterborough town criers.

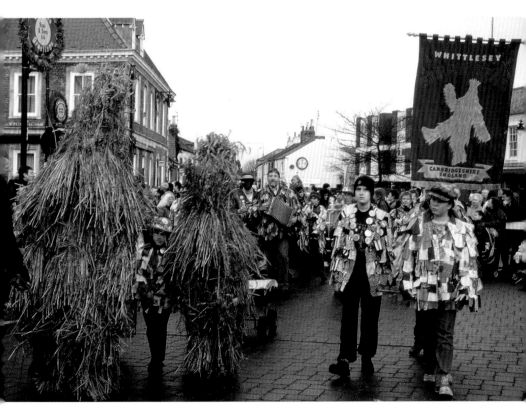

13. Whittlesey Straw Bear Festival.

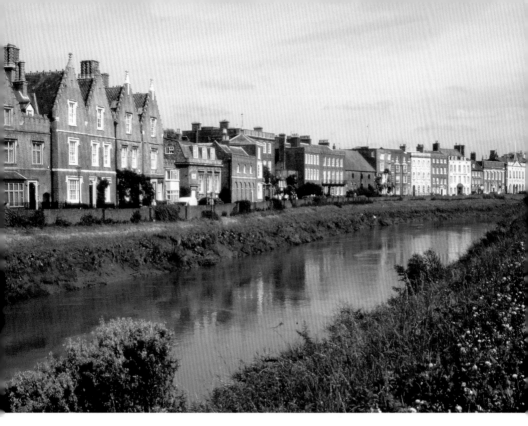

14. Wisbech and the River Nene.

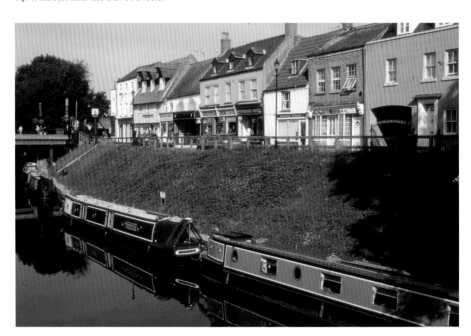

15. Narrowboats on the river at March.

16. Madingley Windmill.

17. The fan tail of
Wilingham Windmill.

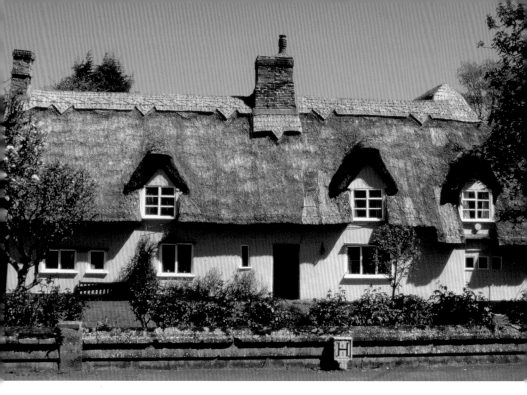

18. Thatched cottage on Great Eversden High Street.

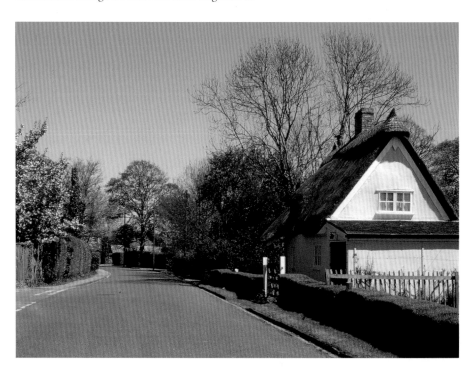

19. The quiet charm of Little Eversden High Street.

20. Chippenham Hall.

21. Elton Hall.

22. Wimpole Hall.

23. Wicken Fen, the windpump, reeds and marshland.

24. The American War Cemetery at Madingley.

25. The heart of Newmarket.

26. One of the painted horses outside the Jockey Club in Newmarket.

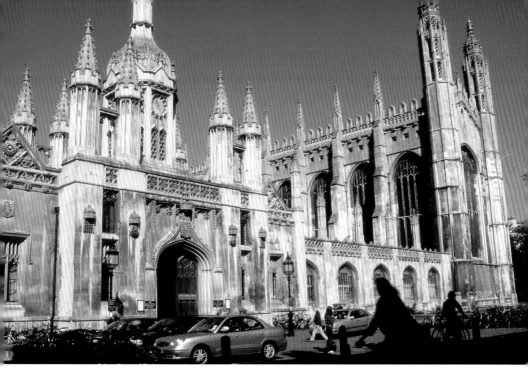

27. King's College. .

28. Cambridge, St Mary's church
and the Central Market.

29. St John's College.

Chatteris, the town centre.

Ancient inns include the seventeenth-century Cross Keys and the George Hotel, once the departure point for the six-horse mail coaches to London and Wisbech. The old brewery is a solid brown stone Victorian block with a chimney stack on one corner. It later became the Cole engineering works where the first carrot washing machine in the country was installed, an important industrial step forward in the agricultural world of the Fens.

Chatteris has been home to many notable personalities but the star of them all has to be Dave 'Boy' Green. Dave was born in Chatteris and went to school here, and now his home and business are here. His success story has come a long way, from farm worker stitching up bags of carrots and loading lorries, through to boxing champion to millionaire businessman. In terms of location, however, he has come full circle.

The home of Dave 'Boy' Green is easy to find, it's called Ringside and there are striking red boxing gloves on top of the gate pillars; almost anyone in Chatteris can direct you there. Dave is the classic story of the local boy made good, the farm worker who fought his way twice to a crack at the World Championship Welterweight title, but never forgot his roots. In his heyday they also called him the 'Fen Tiger', and Chatteris is rightly proud of him.

Dave fought for seven years as an amateur boxer, and then his professional career spanned another seven magnificent years, from December 1974 to November 1981. In June of 1976 he won the British Light Welterweight title, and in December of the same year he took the European Light Welterweight title.

Dave 'Boy' Green and his wife outside their home in Chatteris.

Those were heady days when a Dave Green fight could virtually empty Chatteris and drain the Fens of half its population, as his vast army of fans flooded down to the Albert Hall, Wembley Stadium, or wherever he was fighting. They wore smocks, played the yokel, blew bugles, and howled for the 'Muck Spreader', and the 'Carrot Cruncher', the specialist Dave 'Boy' punches.

In June of 1977 he fought Carlos Palomino the reigning World Welterweight Champion at Wembley. It was a stupendous fight which Dave carried to the eleventh round before his left eye closed and left him blind to a knockout punch. Dave was always a do-or-die fighter, and many people believed that without that fatal eye damage he would have won, the fight was that close.

By March 1980 he had stormed his way to a second chance, and fought the great Sugar Ray Leonard, again for the World Welterweight title, at Landover USA. Again it was a case of almost to the top, but not quite. A thunderous left hook from Leonard smashed through to Dave's chin and his head hit the canvas hard as he crashed down. It was a knockout, but today they are still friends.

His boxing career extended to 105 amateur and forty-one professional fights but it is now over thirty years since Dave 'Boy' last entered the ring in his flamboyant tiger-skin dressing gown. He became a salesman for a packaging and distribution firm, clinching business deals with the same determination to win that had made him successful in the ring. Since then he and his business partner have bought out the firm and built up Renoak Limited to the tune of a £3.5 million annual turnover, making it a substantial part of the local economy, concentrated under seven large warehouse units in Chatteris.

Saints and sinners, George Cross and Victoria Cross heroes, gold prospectors and championship boxers, the unlikely flat Fenlands of the Cambridgeshire Middle Level have produced them all.

CHAPTER NINE

THE AGE OF WINDMILLS

Ever since the thirteenth century, windmills have been a familiar sight in the English countryside, and for centuries their great white sails turned on almost every other hilltop. In mediaeval times in any small town or village the miller was as vital to the community he served as the blacksmith or the village priest.

Cambridgeshire had hundreds of mills in the late Middle Ages, most of them working the necessary drainage pumps of the Fens, but many of them grinding corn. Today many of those mills still remain. One account lists forty-eight extant mills, some without sails, some where the sails stand silent and motionless, and just a precious few that have been returned to perfect working order.

The contenders for the title of the two oldest mills in Cambridgeshire, and possibly the oldest mills in England, are the two sister mills at Bourn and Great Gransden. Both are open trestle post mills. Bourn Windmill can be traced back to 1636 and has been many times repaired and rebuilt. Great Gransden Windmill was first constructed around 1612 and has two storeys with a flour-dressing machine dated 1774 on the second floor. Both of these lovely old black-tarred windmills are now listed as national monuments.

The Wicken Corn Windmill at Wicken village, which celebrated its 200th birthday in 2013 (not to be confused with the smaller but more familiar windpump at nearby Wicken Fen), is another notable survivor of those lost nostalgic days of slow whirling white sails. It has many features that are characteristic and common place of many Cambridgeshire windmills. The black-tarred wooden tower carries a white cap with four 9ft-wide sails each with a span of 63ft. The cap and sails are turned by a blue fantail. The mill was virtually derelict by 1977 when it was repaired and restored. This is a smock windmill, so called because its general shape fits the outline of the old country smock which used to be worn by agricultural labourers.

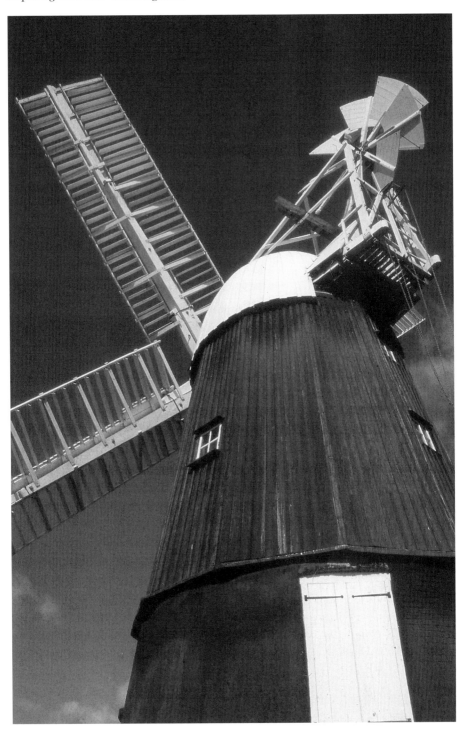

Wicken Windmill.

Fullborn Windmill, which stands on one of the Gog Magog hills just outside Cambridge, is one of the prominent landmarks of Cambridgeshire. Its cap rises 160ft above sea level and gives wide views over the Fens as far away as the cathedral towers of Ely. Originally a drainage mill stood here but it was replaced by the present corn mill in 1808. It is another large, octagonal smock mill with a brick base and a wooden superstructure. In 1933 the windmill was struck by lightning twice during one furious thunderstorm. It went into decline but now a full restoration programme is bringing it all back to its former glory.

A rare working windmill is at Swaffam Prior, a delightful little village which actually has two windmills. As I approached from Newmarket and the Suffolk border both mills stood tall on the skyline, one on either side of the road. The one on the left, although beautifully restored, is now a private home, as still as a Constable painting. The one on the right was active, and was clearly the one I had come primarily to visit, a black-tarred working tower mill with splendid white sails turning bravely in the fierce October breeze.

Jonathan Cook, the present owner and miller at Foster's Mill, was already at work, measuring out the final bags of fine stoneground white flour which is now produced here and sold in shops in Cambridge and the local villages. 'A number of local bakers use our flour every weekend,' Jonathan told me over the continuous rattle of the mill's machinery, 'and the range of breads they produce are very successful. We started at the local level but now we make sales through the internet and have national distribution.'

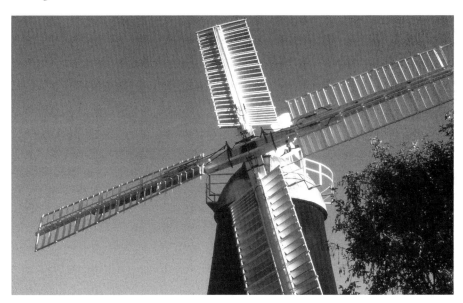

Foster's Mill, the working tower mill at Swaffham Prior.

The records suggest that there has been a succession of mills on the artificial mound of this site since Domesday, although the present mill was built here around 1857 by Fyson's of Soham. For much of its life the mill was owned by the Foster family, who also owned the neighbouring mill on the far side of the road. The far mill produced flour for human consumption during its working life, while the mill in which we were standing originally produced animal feed.

The mill is a four-floor tower mill, constructed with an outer black-tarred brick skin, and an interior of soft clunch that is plastered and then white-limed on the inside. Clunch is the local soft Cambridgeshire chalk. 'Windmills like many other buildings round here were built of materials that were locally available so the Fyson's used locally quarried clunch both here and at the mill at Burwell,' Jonathan informed me.

The great sails can only turn when they are facing into the wind, and this is done automatically by the fantail, the smaller fan behind the sails, which can rotate the whole cap on a ball race whenever it is pushed by a crosswind. The sails then turn the massive, almost vertical, brake wheel that is housed in the cap, which in turn engages and rotates the wallower which transfers power down a vertical central shaft to the great spur wheel that is located between the ground and first floors. The spur wheel, which is an impressive single casting over 10ft in diameter, then drives everything else in the mill.

While Jonathan is telling me all of this a bell starts to ring loudly above our heads. 'That's my signal to tell me that the grain is running low in the hopper,' Jonathan explained, and we moved up to the first floor to tip in another sack of wheat.

Left: Jonathan Cook checking the flow of grain from the hopper into the millstones.

Below: The great spurwheel between the first and ground floors which drives all the auxilliary machinery.

The ground floor is known as the meal floor, because that is where the finished flour finally appears. The first floor is the stone floor, because this is where the actual millstones are housed in their circular wooden tuns. There were two sets of the huge circular French burr stones, which were mined and imported from a site near Paris. The bottom stone of each pair was the bed stone, which remained static on the supporting beams. The upper ones were the runner stones which rotated to crush the grain which was shaken down into the eye of the stone through a wooden shoe from the hopper above.

Jonathan continued to tell me the story of the mill as he worked. The Foster family kept it running through the war years when many mills were put back into action to help the war effort. Then in 1946 it was allowed to stand idle and became derelict. It was sold in 1971 to Michael Bullied, intact but in a very poor state of repair. It was restored with new floors, new sails and new stone furniture, and eventually started grinding corn again in 1989.

Jonathan and his partner bought the mill in May 1998. Tragically Michael Bullied died soon after, but it was his wish to see the tradition of milling in Swaffham Prior carried forward into the next millennium, something that Jonathan has been happy to ensure.

'Michael had to stop running the mill two years or so before we bought it,' Jonathan said as we stood and watched the millstones revolve. 'But it was in a workable state. When we started it up we found that both suppliers and customers were interested in what we were doing and quite happy to work with us again, so there were no problems in either obtaining the grain or selling the flour. We now use local organic grain, so all our flour is milled from organic wheat.

'Quite a few of the mills that are still working today have turned to producing organic flour which is very popular with people who enjoy baking their own bread. Traditional mills are well placed to work with local farms, sourcing quality, tasty grain which they can mill and then sell on to bakers and direct customers linking the farmer, miller and consumer together, much as would have happened 200 years ago. We've gone full circle, the customer today looks for a product that tastes great and has provenance and is sourced locally.'

The mill now produces a whole range of flours, including wholemeal flour, white flour, brown flour, rye flour, semolina and spelt flour. 'Semolina, which means semi-milled flour, is a grade of flour often used in biscuit-making, and normally if you see it in the shops it's made from Durham wheat,' Jonathan enlightened me. 'Spelt grain is a grain that dates back to Roman times, and is therefore an older variety of grain than the grain we now know as wheat today.'

There were two floors left to see. The third floor, or bin floor, immediately above the stone floor, is where the grain is hoisted up and stored. And above that the dust floor, which was basically an empty level which helped to protect the

lower workings of the mill from all the dust and grime which filters in from the top. Up here the great wallower, and above it the brake wheel turned by the sails, were both rumbling in steady circles just above our heads.

'There's an iron band round the brake wheel which will stop the mill when necessary,' Jonathan pointed out. 'But in Cambridgeshire it's a tradition to leave the brake off, so that first thing in the morning, like this morning which was very gusty, you can come out and find the sails already turning without the machinery being in gear.'

Jonathan's commitment to his mill and to milling is evident in his roles as Vice Chairman of the Mills Section of the Society for the Protection of Ancient Buildings and as Secretary of the Traditional Cornmiller's Guild. Jonathan explained that there are only some thirty-five guild members, with a handful of associated members, but all of them are primarily producing power by the natural means of either wind or water power.

The wind and watermills which guild members have restored and are maintaining are all beautiful historical buildings in their own right. But they are not just museum pieces reflecting the nostalgia of a past age. The guild does aim to promote a public awareness of those who are preserving our ancient traditions and heritage, but equally as important is the production of a natural food resource which will not damage the environment.

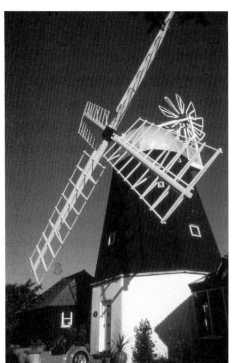

Milling is hard, dusty work, and a constant, noisy assault upon the ears, but I began to understand something of Jonathan's satisfaction with his job as I watched him deftly switching on and off the stream of finished white flour as he measured it carefully into paper bags. It was good to know that at least some of our daily bread is still made from flour produced in the traditional way. 'And it tastes better too,' Jonathan assured me.

Looking out from one of the small upper windows there was a clear view of the stationary sails of Swaffham Prior's second windmill on the far side of the road. This one was a handsome

The black timber smock mill which was once a working partner of the Foster tower mill.

vertical board smock mill that is now a private home. It had been splendidly restored by a succession of previous owners who had added three neat extensions on either side and behind the mill to give added ground space. It had been freshly painted, black to offset the pure white sails, and prompted Jonathan to remark that it was nice that it was still there and that it still looked like a real windmill.

I had to visit the two churches before I left Swaffham Prior, if only because it is so unusual to find two churches in the same churchyard. They stand side by side, two proud towers rising above the treetops on the small, dominant hill in the centre of the village.

Their historical background seems a little hazy in places, but the little guidebook on sale in the village suggests that the oldest church, dedicated to St Cyriac and St Julitta, was probably founded by some of the Norman knights who arrived with William the Conqueror. St Cyriac was the French saint better known as Saint Cyr, and Saint Julitta was his mother. They were martyred during one of the terrible Roman persecutions of Christians around AD 304, when the boy was only 3 years old.

The slightly later second church is dedicated to the Virgin Mary. Perhaps a growing population needed two churches or perhaps the native Saxons preferred to choose whom they worshipped rather than have the French saints imposed upon them. However it came about, the two churches served separate parishes within Swaffham Prior for centuries, with the two great mediaeval abbeys at Anglesey and Ely each claiming one church, and the tithes it generated, as their own.

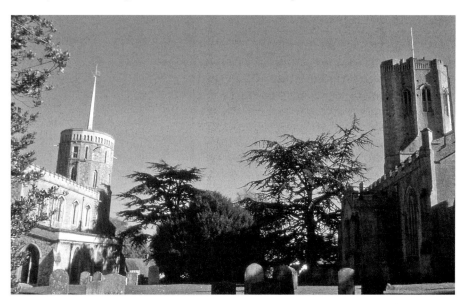

Two churches in one churchyard. St Cyriac's is on the left, St Mary's on the right.

By the beginning of the nineteenth century both churches were in a state of disrepair. St Cyriac's was a tower without a church, while St Mary's, having been virtually decapitated by a lightning bolt, was a church without a tower. Both have since been restored, and St Mary's seems to have at last come out on top in the long confusing history of the two churches, as it is here that today's regular church services are held.

The two church towers and the two windmills make up one of the more attractive of the ancient skylines of Cambridgeshire, but all around the county there are flat expanses of fenland that are rapidly filling up with a new kind of windmill.

These are the wind farms that in many places make up the modern skylines with their orderly rows of tall, white, steel pylons and sweeping circles of white, steel blades. In 2011 there were eighty-one of these giant white wind turbines operating, spread over ten wind farm sites in Cambridgeshire. Six more wind farms were in the planning stage. With global warming and the harmful rate of global climate change increasing it seems almost certain that the proliferation of wind turbines will also accelerate. Carbon dioxide emissions from the old coal and gas burning energy stations are seen as one of the main causes of global warming, but energy and electrical power are still in insatiable demand. The earth's oil and gas supplies are running out and we need alternative sources of clean renewable power. The wind farms have their limitations and their opponents but it seems they are here to stay.

For conservationists the slicing swish of steel blades will never replace the creak and rattle of real windmills with their wooden and canvas sails but they do have a certain lofty majesty of their own as they march across the wide fen landscapes.

CHAPTER TEN

VILLAGE PORTRAITS

The *Cambridgeshire Village Book*, compiled by the Cambridgeshire Federation of Women's Institutes, lists over 200 villages in the county. Some of them are small, some large, some of them tucked away in almost hidden corners of the Fens, but all are thriving little communities which, with the larger towns and cities, help to make up the social bustle and human heart of this charming county.

Some of them are famous for their sights, a windmill or a church, an old abbey or a particularly beautiful waterway location, or perhaps a haven of thatched roofs and flower-decked cottages around an ancient village green.

A few are well known for their annual events. The tiny village of Thriplow gives the tourist season a spring kick-start with its annual Daffodil Weekend. Only 450 people live in this tiny village of quiet lanes surrounded by fields, woodlands and orchards in the rural farmlands just 7 miles south of Cambridge, but at the end of March Thriplow and neighbouring Heathfield are both awash with thousands of daffodils.

The waving, waxy yellow trumpets form a virtual golden sea that flows breezily between the houses. Almost every household takes part. The centre of the village is closed to traffic for this joyful celebration and there is a whole range of entertainments from heavy horse dray rides to morris dancing to add to the festive air. The village blacksmith gives working demonstrations in the old smithy. The event began in 1963 to raise money for the local school and the church restoration fund. Now it pulls crowds of thousands of visitors and has raised funds for a succession of charities and local needs.

Move on to May Day and there is another unique Cambridgeshire event as the crowds gather in the village of Stilton, about 5 miles south of Peterborough,

to watch the teams competing in the annual cheese-rolling contest. The teams, many of them in various forms of fancy dress, bowl large slices of sawn off telegraph pole painted to look like cheese down the High Street. The winning team is awarded a crate of beer, a real Stilton cheese and the honour of styling themselves the Stilton Cheese Rolling Champions.

The event passed its fiftieth anniversary in 2009 and grows ever more popular with the usual fairground atmosphere, plus live music and maypole dancing thrown in for good measure. However, those who look for the cheese factory will look in vain. The cheese was never manufactured here. Instead it achieved its fame because it was sold in one of the pubs, probably the ancient Bell which still stands in the village centre close to the village pump. This was back in the days when Stilton was an important coach stop on the Great North Road and the taste of a 'Stilton' cheese came to be regarded as a gourmet highlight for hungry travellers.

A third day out with a difference is provided by the small village of Witcham on the A142 just outside Ely. Here the World Pea Shooting Championships are held every year as part of the village fete. A target, 1ft in diameter, is set up on the village green and coated with putty so that the peas will stick to the target on impact. Contestants fire from a distance of 12yds and although most are local some now come from all over the world. The competition celebrated its fortieth anniversary in 2010 when more than 100 hopeful sharpshooters took part.

The idea was born with the local schoolmaster when he took stock of the large number of pea shooters that had been confiscated from the mischievous schoolboys in his classroom. A fund-raising idea was needed for the village hall and a pea shooting competition seemed an ideal fun event as part of the general money making.

The competition was a success and has come a long way from a simple schoolboy puff with a pith-removed elder stick and a dried pea. The peas are supplied by the organisers, five shots for each competitor, all smooth, round without wrinkles and no more than 5.5mm in diameter. The pea shooters are a standard 12 inches in length but the technology has improved. Rifle sights on gleaming metallic tubes are now common and one contestant even boasted a gyroscopic balancing mechanism in addition to its hyper-accurate laser sight. He won the championship three times. The sport is taken very seriously and has become much more complicated than just suck, spit and blow.

The turn of the millennium gave every community the opportunity to do something to show off its talents and flaunt its pride. Most of us celebrated with a joyful party on the New Year's Eve and stretched it well into the early hours of 1 January. However, in the neighbouring villages of Castle Camps and Shudy Camps they did much better than that. The Millennium Committee for the two villages worked for three years to build up to their grand climax.

Charming country cottages at Castle Camps.

The Camps are tucked away down in the south-eastern corner of Cambridgeshire where the borders with Suffolk and Essex meet. Castle Camps, the larger of the two, is a charming little village liberally sprinkled with thatched and country cottages, with a population of just over 400. Shudy Camps has a population of around 120.

Castle Camps has a past that goes back to Domesday, and can stake its claim in both mediaeval and modern history. It is also a forward-looking village with a thriving community spirit. The Millennium story proves that.

There was probably a Saxon fortress here before the Normans stormed over in 1066. After the Conquest the castle that gave Castle Camps its name was built. There is little remaining now of the castle, just earth mounds marking the site of the old motte and bailey walls. There is also little left of the original, mediaeval village of Castle Camps, which was abandoned after the Black Death struck England in 1348. The present village is now more than a mile away from the original site, leaving All Saints' church, which was probably built around the same time as the castle, standing somewhat aloof from the community it now serves.

Castle Camp's claim to a place in modern history lies in the airfield that was opened there in 1939. Now it is all farmland, marked by a simple memorial as you enter the village on the road from Steeple Bumpstead. Some of the old runways still exist as farm roads and tracks, and a few of the old Nissen huts are still used as farm buildings.

All is quiet now, except for the occasional sound of a tractor, and on a stormy day the wheeling of seagulls, but during those desperate war years between 1940 and 1945, things were very different. The skies reverberated with the thunderous roar of Spitfires, Hurricanes, Blenheims, Moths and Hornets. A whole succession of Mosquito squadrons were stationed here, an ideal home for a plane that was then Britain's latest top-secret fighter

It is all in the past now, but the peace and tranquillity that is Castle Camps today is all part of what their valour achieved. However, don't be misled by all this quiet, rural charm. Like most Cambridgeshire villages there is a lot going on here and when they put their minds to something they get it done.

They were determined to celebrate the Millennium but unlike the larger towns and cities there was no money for the celebrations, so celebrating and fund-raising had to go hand in hand. They started with simple jumble sales, disco dances and for something really different an Auction of Promises. The auction was held in the village hall where promises to cut lawns, dig gardens, cook meals or any other service they could think of were sold to the highest bidder. It was fun, it raised money, and it showed what even the smallest village could do when its inhabitants worked together.

There was a children's party and a tea dance for the senior citizens where all the waitresses wore 1920s-style period pinafore dresses. Finally they raised enough money to finance the big event, a massive Music for the Millennium Concert featuring the Opus One Big Band.

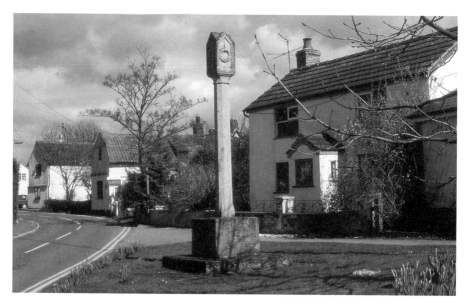

The war memorial stands on the crossroads at Castle Camps.

The band was founded as a large Glenn Miller-style orchestra to play all the venues celebrating the fiftieth anniversary of the Second World War, and has since remained as Britain's foremost nostalgia band, playing music from the 1920s to the present day. But little Castle Camps thinks big, and for their Millennium climax only the best would do.

Every community did its best to commemorate the Millennium but just one more example will have to suffice. 'Quiet Lanes and Orchard Ends' are words written by A.C. Benson to describe the Eversdens, two small adjoining villages in the heart of rural Cambridgeshire. It is now also the title of a splendid book, written to celebrate the Millennium in Great and Little Eversden, lavishly illustrated with old photographs taken over the past 100 years.

To learn more about the book I talked to Lindi Wood, who has researched, compiled and written this handsome legacy for future generations. But first there was time to explore the peaceful charm of the Eversdens. Situated just off the A603, south-west of Cambridge, there was no through traffic, and the main sounds were bird songs. It was a glorious May morning, with pink and white blossom spilling skyward and cascading heavily over almost every fence and hedgerow.

The heart of Great Eversden was the High Street, where the black and white timbered post office and general store nestled between heavily thatched cottages. Opposite was the seventeenth-century, timber-framed Moat House, set back a little behind more blossoming fruit trees, and the Old Granary which is now converted into a spacious modern home. To the west, where the High Street made a sharp bend, was another time-weathered, seventeenth-century building, Manor Farm, built within a double moat and screened by a graceful avenue of trees in their new spring green.

Looking east from the High Street was St Mary's church, its solid square bell tower rising above an encircling screen of mature chestnut trees. The church was almost entirely rebuilt in the late fifteenth century after being damaged by a lightning strike and fire. Lightning struck the tower again in 1975, proving that lightning can indeed strike twice.

The church of Saint Helen in Little Eversden was more difficult to find, a turn down Little Eversden High Street, and another turn up Church Lane, but it was well worth the effort. With a similar square bell tower and slated roofs, St Helen's is predominately of fourteenth-century construction with later restorations. Again it was shaded and peaceful, and surrounded by a wall of clunch, the soft Cambridgeshire chalky stone, which was quarried locally until at least the eighteenth century.

I dipped into all those quiet and shady lanes. At the end of Buck's Lane was Five Gables Farm, a beautiful timber-framed and plastered farmhouse with a fifteenth-century nucleus. At the end of Wimpole Road was Merry's Farm,

Eversden, a village of Quiet Lanes ...

an L-shaped, white-walled, thatched jewel, again dating back to the seventeenth century. There were modern houses too, but it did seem that round every narrow turning in both Great and Little Eversden there was yet another nostalgic reminder of the rural past.

And, of course, every lane seemed to end in a meandering footpath that continued out into the fields and countryside. There were footpath signs everywhere, and the villages and their surroundings are obviously popular with walkers.

At the end of my explorations I did the same as most ramblers probably do, and went for lunch in The Hoops inn, the last of the Eversdens four pubs. The others are long gone, or converted into homes, but The Hoops, with its barrel-maker's sign, still offers fresh cooked food and good ale.

At last it was time to meet the wonderful Lindi Wood. I had purchased a copy of *Quiet Lanes and Orchard Ends* in The Hoops, and we sat in the warm afternoon sunshine in her garden to browse through its pages.

'The book is our celebration of the Millennium,' Lindi explained. 'Although at first we didn't know that it was going to be a book. It began when Mary Green put together our Millennium Group. There were sixteen of us, and at first we concentrated on fund-raising, because until we knew how much money we could raise no one knew what we could afford to do. In the end we raised just over £12,000 from village events, some premium bond prizes from the money we invested as it came in, and from a Millennium Festival for All Award.

... and Orchard Ends.

'Then we had to decide what to do with the money and lots of people put in lots of different ideas. We had a village vote and finally we settled on the idea of doing the book, mainly because we could draw upon this wonderful archive of old photographs that has been collected over the years by Derrick Mallows. There are about 150 photographs in the book and about ninety of those came from Derrick. He has been collecting this archive of the Eversdens for over forty years.'

I asked her how she came to get the job of writing and compiling the book and she laughed. 'Well, I had just finished my degree course as a mature student, and I'd got a first for my thesis, so they all thought that qualified me for the job of author. My interest is in art and history, and I did my degree half in art history and half in fine art, and majored in sculpture. But half the degree work was essay writing and the committee knew this.

'They felt that if we did the book as a committee, with different people contributing, then it would not flow so well, and perhaps look a bit piecemeal. So they decided that if one person would do it all and be committed to it, then they would all support that one person – and they asked me. It was great fun, and there was marvellous support from everybody on the committee and in the villages.'

The 144 page, 8 × 10 inch volume, was beautifully bound in bottle-green hardback with the title gold embossed on the spine, and a cover picture on the jacket depicting one of those lovely Eversden orchards in full blossom.

'We wanted something worth keeping,' Lindi said. 'A book for posterity. We had a print run of 1,250, and we had a book launch and gave out a free

Thatched cottages on Great Eversden High Street.

copy to every household. Some copies have gone into the Cambridgeshire libraries, and the rest we are selling. Any residual money will go toward new play equipment for the children of the parish, so although the book is largely looking back, the money will be going forward for the children.'

She turned the pages, explaining how each photograph captured the flavour of its time and period, and how she had tried to find something different, either a drawing or a painting to break up the chapter headings. For the chapter on the local pubs she had tracked down a beermat showing the unusual black and white crow that had been the symbol of the old J&J.E. Phillips Royston Brewery. She had found old press cuttings and ancient pen-scrawled bills and invoices to reflect aspects of local prices and history.

She stopped at a picture of the village sign surmounted by a large black boar standing proud on a hill before St Helen's church tower. 'Eversden is listed in the Domesday book' she told me. 'The original name was the Saxon word for Boar's Hill, which is why the boar is on the sign. So we thought it would be fun to draw in the black boar in Eversden Wood on the maps. And we've put him here, too, on the fly leaves.'

'It's been a wonderful project,' she concluded. 'And it has pulled people together in the community. Mike Petty, a local historian who writes for the *Cambridge Evening News*, launched the book for us in the village hall. We had different village groups singing and playing music throughout the day, and at

six o'clock we broke open the wine. It was a lovely party atmosphere with a really nice community feeling. Everybody was talking about their memories, and there were so many happy, smiling faces.'

We looked through the last chapters of the book, with its old photographs of past rural, working, and social life. There were school groups, cricket teams, fruit pickers, shooting parties, the wartime fire brigade, and many more. They were character-filled faces, fashions and lifestyles, all frozen in time and captured lovingly by the camera. It was a work to treasure for the people of Great and Little Eversden, and a useful guide and companion for any stranger hoping to get closer to the spirit of those quiet lanes and shaded orchards.

The clearly drawn maps showed everything, past and present. All the footpaths were marked, the field boundaries and the brooks, and the location of every one of those captivating old houses, farms and cottages. The Eversdens are well worth exploring, and if you have the time do find out if there really is a shy black boar hiding somewhere in the dappled glades of Eversden Wood.

Inviting stiles and footpaths lead off many of the quiet lanes into the surrounding countryside.

CHAPTER ELEVEN

CHIPPENHAM –
A PORTRAIT OF AN ESTATE

The casual visitor passing through Chippenham could be forgiven for thinking that they had driven into a time warp. Outwardly it has hardly changed from the pre-war days when the village was virtually feudal, existing only to serve the great hall and the park estate. The lovely row of pink and yellow William and Mary cottages that once housed the estate workers leads into the High Street. Beyond them is the beautiful old Georgian building that was the Queen Anne school. The Old Bakery dating from Tudor times, the eleventh-century church of St Margaret, and the old village pump are all still there.

All of them are listed buildings, and most of them have been rebuilt and totally renovated inside to create modern homes. The only new housing estate at Scotland End is tucked away out of sight, leaving the actual village with its almost mediaeval outer appearance intact.

And Chippenham was a mediaeval village. Its recorded history, described in detail in *Chippenham, an East Anglian Estate Village* by M.J. Ross, goes back to William the Conqueror, who gave the manor of Chippenham to one of his knights, Geoffrey de Mandeville, after the Norman Conquest. Geoffrey's son William gave it in turn to the Order of the Knights Hospitallers of St John of Jerusalem in 1184, and the Knights were Lords of Chippenham for the next 300 years.

The Order was founded to protect a hospital in Jerusalem, and then to help the sick and needy among the many twelfth-century pilgrims to the Holy Lands. It became a military as well as a religious order during the Crusades. Its Preceptory at Chippenham, with its hall and infirmary built where the old Queen Anne schoolhouse now stands, opposite St Margaret's church, was one of the most important in England. The churchyard contains the graves of at

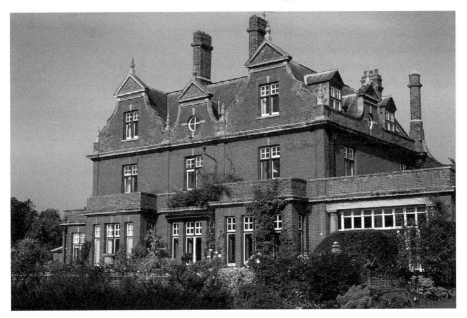

Chippenham Hall.

least two of the Knights. There is also an underground passage, now sealed, that passes under the High Street from the church to the old school, although this is believed to date from later Cromwellian times.

The Order of St John was suppressed in England in 1540, but look closely and a knight in armour can still be seen riding past the old church – although now he is only a carved figure on the village sign.

With the departure of the Knights the manor passed to the Russells, who were Baronets of Chippenham for the next century. Chippenham Hall was built in the mid-seventeenth century, and the estate became a park in the early eighteenth century. Finally, in 1792, the estate was sold to John Tharp, the great-great-grandson of one of the first English settlers in Jamaica, where the family fortune had been made on the sugar plantations.

Chippenham Hall was rebuilt and enlarged around 1890, about the same time that the public house, the old Hope Inn, was renamed as the Tharp Arms. The pub sign shows the coat of arms of the Tharp family, and is surmounted by the mysterious Tharp Lady holding an anchor. A stone image of the Tharp Lady also stands over the magnificent main gateway between the south lodges that framed the start of the 3-mile drive to the hall from the Old Bury–Newmarket road. Legend says that at midnight on New Year's Eve the Lady will come down from the gateway and dance, but as the old entrance is now unseen from today's main road there are no witnesses.

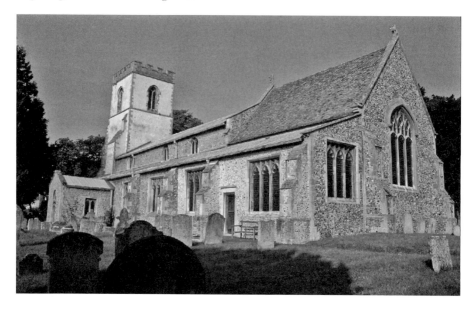

St Margaret's church.

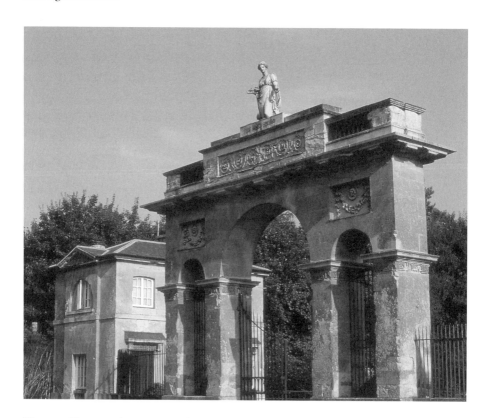

The magnificent south entrance to the park.

During the early 1900s the Tharps and Chippenham Hall played host to many of the aristocracy and often to royalty. The growing popularity of racing at nearby Newmarket brought many of the titled heads of England down from London, and Chippenham became equally popular as one of the country's leading shooting properties. Partridges, pheasants and hares were shot in vast numbers. Even today, on a crisp autumn or winter's morning, you may still hear the bark of dogs and the bangs of guns as the pheasants are flushed from the long grass and bracken, the last echoes of a glorious Victorian heyday.

In those days more than a 100 people worked on the estate, the entire working populations of the two villages of Chippenham and Snailwell. Today, with the advent of modern farm methods and machinery, that number is down to a mere handful. The huge post-war social and economic changes in the rural landscape almost killed the villages that had previously seen their role only as a part of the great estate. Through lack of work, housing and modern amenities the village population dropped, until Chippenham's vicar in the 1970s expressed his frequent soul-felt lament that, 'The village is dying!'

His words seemed proved in 1978 when the Queen Anne School was finally closed. With two teachers and only eleven pupils it was no longer viable.

And then the rebirth began.

Mrs Anne Crawley, a fifth-generation descendant of John Tharp of Jamaica, inherited the estate, where she lived in the central part of the hall with her husband Eustace until her sad death in June 2011. The two wings are let out to two tenants, and farming is now done in a partnership between the estate and a local farmer. The estate itself is now reduced to 3,000 acres, less than half of the approximately 7,000 acres it had comprised at its largest extent. Times had changed, and the once magnificent stable block and many other estate properties were in disrepair and falling down. Changes were desperately needed, but those changes were thoughtfully and lovingly made.

When I met them, on a pleasant evening in early September, the Crawleys were pleased and enthusiastic in driving me around the estate and village to show me what had been achieved. Much of the estate had to be sold off and redeveloped, but the Crawleys had worked hard to make sure that all the areas of redevelopment were in keeping with the essence of the old village. The old stable block has now been converted into six houses and two flats, and virtually every building along the High Street has been renovated or rebuilt.

They showed me New Street, where Admiral Lord Orford, probably the most dynamic of the Russell baronets, had built new houses for his cottagers 300 years before. The last one still survives, although completely rebuilt, an idyllic picture in pink, with a profusion of hanging flower baskets.

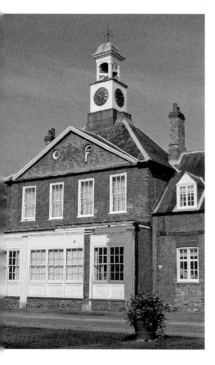

Left: The old stable block now renovated into flats and houses.
Above: The William and Mary estate cottages.

More than half the High Street consists of listed properties which have all been completely refurbished, and where there were, until recently, only cowsheds and pig sheds there are now tasteful new bungalows and houses built by their new owners. Everything possible has been done to create a thriving new community living in modern homes with modern amenities, while still retaining the unique outward appearance of the old estate village.

Even the brand new housing estate at Scotland End is a model of neat elegance. Every house is slightly different, with little replicas of the clock tower from the old stable block on the estate incorporated into the roof design of the necessary garages. Most of the money from the sale of the Scotland End land was used to rebuild the last two pairs of the William and Mary cottages, now converted into single luxury residences, and to build the brand new village hall.

'There was uproar when the land was sold,' Mr Crawley recalled. 'But because we were renovating all the old houses from blocks of two or three into one the total of houses was getting smaller, so we did need to build more houses.'

Now, they both claimed that the rebuilding of the village had been an enormous success. The new housing had attracted in new people, and fortunately Chippenham is far enough from London to escape being a typical commuter village, where long haul-travel to and from the office leaves no energy for any kind of village life. Chippenham commuters tend to travel no further than Cambridge, Bury St Edmunds or Ely to their workplace, and so,

Cricket on the green.

again in the words of Mr Crawley, 'There is a thriving new village spirit of tremendous vitality. Everything here has been achieved by the co-operation and efforts of the whole village.'

This was demonstrated by the brand new cricket pitch, tennis courts and the rather older bowling green, all built with great energy by the new villagers. The land was provided by the Chippenham Estate. The East Cambridgeshire District Council and a grant from the Foundation for Sport and the Arts provided most of the money. The village provided the volunteer labour with just one paid consultant to oversee the entire project.

'We grazed cows here seven years ago,' the Crawleys told me proudly as we surveyed the cricket pitch. 'Now they play junior county matches here.'

It seemed to me that they had every reason to be proud, and so has the whole village of Chippenham as the new blood moves it smoothly and confidently from its feudal past into the bright new challenges of the new Millennium. Don't be deceived, casual visitor, Chippenham is not really in a time warp – it is a very pleasant, progressive and active place in which to live.

CHAPTER TWELVE

STATELY HALLS AND SPLENDID HOUSES

Wimpole Hall has the pride of place in being the largest and most elegant stately hall in Cambridgeshire. It is a wide-winged red and white brick mansion set in its own glorious gardens and parkland with a treasure house interior of magnificent rooms and galleries. The house has evolved over 350 years with many changes of ownership, and the accumulation of lands and manors that form the vast estate go back to the twelfth century.

Wimpole has always occupied a prime position close to Cambridge and adjoining the Great North Road which was first a prehistoric track and then a Roman highway to York as well as a direct link south to London. It meant that those who owned Wimpole could combine the life of a country gentleman with the power play of politics and the social whirl of the capital. Philip the 1st Earl of Hardwicke who acquired Wimpole Hall in 1740 was Lord Chancellor to George II.

The house had previously been owned by the Harleys who were the earls of Oxford, and before them by the Chichleys who had dominated most of south-western Cambridgeshire for 250 years. Sir Thomas Chichley began the building of the first stage of Wimpole Hall just before the beginning of the English Civil War. Sir Thomas took the king's side in those turbulent years and found himself under a cloud until after the restoration of the monarchy with King Charles II.

Despite his return to royal favour Chichley eventually had to sell off the Wimpole estate. He kept a London town house in Covent Garden and enjoyed a lavish lifestyle. All of this plus the cost of building Wimpole and adding the surrounding deer park proved too much. Wimpole passed to the Duke of Newcastle. Newcastle's daughter married Edward Lord Harley and the Harleys owned Wimpole from the reign of Queen Ann until 1740.

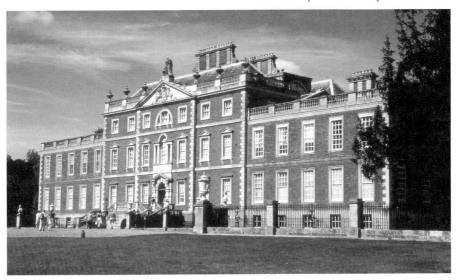

Wimpole Hall.

The Hardwicke reign at Wimpole came to an end with the 5th Earl, the notorious 'Champagne Charlie' and so-called 'Glossy Peer', who managed to fritter it all away. The 5th Earl was one of the principal dandies whirling in the glitzy court of the Prince of Wales and managed to lose almost the entire family fortune at the noble sport of horse racing. His term of residency at Wimpole had been reduced to the shooting seasons only and so the house and the estate had to go.

The house failed to reach its sale price and was taken over by Lord Robartes in his capacity as Chairman of the Agar-Robartes Bank. Finally the house became a property of the National Trust. With its ornate ceilings, sumptuous carpets, great staircase and lavishly furnished bedrooms and drawing rooms it is now the Trust's premier showpiece in Cambridgeshire. The magnificent library houses a vast collection of books and the arrays of pictures, sculptures and works of art are dazzling.

The gardens and landscaped park include splendid avenues radiating south, west and east, the estate church, lakes and woods. The stables, like the hall, are of classic red brick dressed with white stone, plus a central clock tower. There is a Chinese bridge and the almost inevitable gothic folly. The latter is a crumbling grey tower that could have been drawn from some mediaeval or Tolkienian fantasy.

The Wimpole Home Farm, a short stroll or a short horse-drawn wagon ride through the grounds, is a working eighteenth-century model farm that is also open to visitors. Focused around a historic thatched great barn it is child-friendly with ample opportunities to meet the horses, the donkeys, the chicks and the goats. It is also the largest rare breed centre in East Anglia.

Shire horses and carriage rides at Wimpole Hall.

The second major National Trust property in Cambridgeshire is Peckover House, a beautiful Georgian brick town house on the North Brink embankment which overlooks the river at Wisbech. Behind its deceptively bland, four-square brick façade it has a gorgeous 2-acre Victorian walled garden filled with summer roses and herbaceous borders. In spring the displays change to banks of daffodils, narcissi and tulips. It has a lily-filled pond flanked with clipped yew hedges, a croquet lawn and a glasshouse orangery with 300-year-old Chinese orange trees. Except in winter when it can be softly blanketed in snow the air is generally filled with the fragrant scents of fruit and flower blossom.

The house was built around 1722 and changed hands a few times before being bought by Jonathon Peckover in 1794. Peckover had established a grocer's shop in Wisbech and from this a small bank was born. Peckover began by holding a few accounts for his grocery customers and eventually entered into a partnership with the Quaker bankers, Gurney and Co. of Norwich. The bank prospered and the family wealth grew until 1896 when the Peckover Bank was amalgamated with nineteen other private banks into the great national Barclays Bank which we know today.

In addition to their founding role in banking, the Peckovers played an important part in the history of Wisbech. By the eighteenth century they owned four substantial properties on the fashionable North Brink. They were keen travellers and collectors as well as Quakers and philanthropists who championed the causes of pacifism and the abolition of slavery.

Peckover House.

There is one more splendid stately home in Cambridgeshire and that is Elton Hall which sits in 200 acres of gardens and parkland beside the River Nene on the western boundary of the county. This massive grey-stone mansion has half the appearance of a castle with its battlemented towers. It has been the home of the influential Proby family since the beginning of the seventeenth century.

Like most of the high-ranking lineages who have developed the stately halls of England as their family homes the Probys have served their country in a variety of power-wielding roles. They acquired Elton Hall back in the sixteenth century when Sir Peter Proby was both Lord Mayor of London and Comptroller of the Household to Queen Elizabeth I. Before that the house had belonged to the Sapcotes who had built the central tower, which still survives and still bears their coat of arms.

Sir Peter's grandson, William Proby, was part of Great Britain's grand strategy in extending the further reaches of the British Empire. He was a member of the British East India Company and Governor of Fort St George in Madras. In the reign of George III, between 1800 and 1802, another Proby, John Joshua, was Britain's ambassador to Berlin and her Special Emissary to the Imperial Court in Russia.

The house today has an impressive appearance, its robust, crenulated walls gentled by the setting of luxuriant gardens overflowing with roses and broken up by still pools and elegant statuary. The interior has a marble entrance hall and

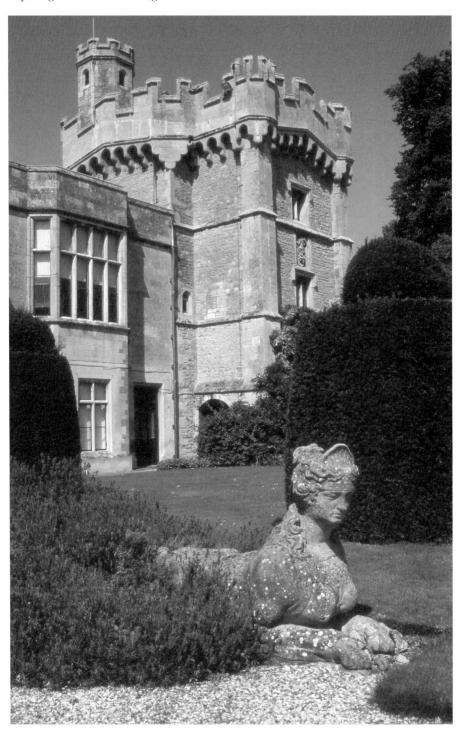

Elton Hall.

staircase and the drawing rooms and bedrooms contain the usual eye-dazzling collections of furnishings, pictures and objects of art that are standard in any English stately hall.

There are two more notable buildings in what was Huntingdonshire. They are Buckden Towers and Hinchingfield House. The first we have already seen briefly in our journey along the first stretch of the River Ouse.

Buckden Towers is a twelfth-century moated manor house but with its massive red-brick towers it stands as square and solid as a castle.

It was the former palace of the bishops of Lincoln and as Chancellor or Keeper of the Great Seal many of them were heavily involved in the power dealings of the state and capital. Five of them are buried in the parish church of St Mary's which stands close by. Situated midway between London and Lincoln on the Great North Road the palace also saw a long stream of royal visitors, from Henry III in 1248 to the Prince Regent in 1814.

The bishops stayed in residence until 1842 but their legacy and the air of spirituality remains as today Buckden Towers is used as a Christian retreat and conference centre. The grounds and gardens are open to visitors.

Elton Hall and gardens.

Not far from Huntingdon is Hinchingbrooke, a splendid Tudor country house built on the site of an ancient Benedictine nunnery. After the Dissolution of the Monasteries, Sir Richard Cromwell acquired the house from Henry VIII. Then, in 1627, the house passed to the Montagu family who were soon to become the earls of Sandwich.

Sir Sydney Montagu, who purchased the hall, was a firm Royalist but his son Edward switched sides and fought as a colonel in Cromwell's Parliamentarian army during the English Civil War. After Charles I was captured, the king was briefly accommodated at Hinchingbrooke on his way from Holmby House to Newmarket. The execution of the king must have seemed a step too far because afterwards Edward Montagu had a change of heart and reverted back to his father's cause and helped to restore Charles II to the throne. He collected the new king from his exile in France and brought him back to England.

Elevated by three titles to Baron Montagu of St Neots, Viscount Hinchingbrooke and the Earl of Sandwich, Edward Montagu finally died as captain of a squadron of ships fighting off a Dutch invasion in Sole Bay off the Suffolk coast in 1672.

The Montagu family's second claim to fame lies with the 4th Earl of Sandwich who refused to leave a winning streak when he became hungry and called for a slice of beef between two slices of bread to be brought to his card table. The great British achievement the 'Sandwich' was named on the spot.

In 1970, Hinchingbrooke House became the sixth form centre for Hinchingbrooke School. It is still open to the public on Sunday afternoons in summer.

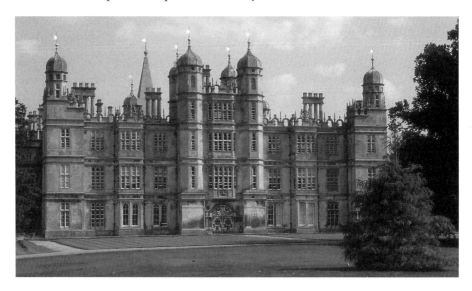

Burghley House.

Our last and most magnificent stately home, which just escapes being in Cambridgeshire by a mere mile or two, is Burghley House. This splendid edifice with its dome-capped towers looks almost like some mediaeval French château transported from the heart of the Loire Valley. It lies just over the county border. However, it is so close, within easy reach of Peterborough, that no resident or visitor to Cambridgeshire with an interest in stately halls would want to miss it.

Burghley was built by William Cecil, Lord Burghley, who was principal secretary and later Lord Treasurer to Queen Elizabeth I. He was her most trusted advisor and rewarded himself by building a monolithic palace and founding a dynasty. His son was made Earl of Exeter and the family have lived here ever since.

The huge house has thirty-five major rooms and more than eighty lesser rooms, together with its numerous connecting halls and corridors. The visitor's tour of the house passes through the ground and first floors and covers nearly a quarter of a mile. Between the many pinnacles and turrets and the seventy-six stone chimneys that make a veritable stone forest on the roof the lead-covered area extends to three quarters of an acre. The rest is roofed with slate and the overall roof area is approximately 1.5 acres.

Everywhere inside there are magnificently ornate ceilings, paintings, tapestries and furnishings. Every room is an Aladdin's cave of riches and treasures collected from all over Europe. Virtually every item is or appears to be priceless.

The sumptuous chapel is dominated by a magnificent altarpiece which depicts Zebedee's wife petitioning the Lord. The billiard room is panelled in dark Norwegian oak and filled with family portraits. The breathtaking Heaven Room is filled with Antonio Verrio's masterpiece work depicting gambolling gods and goddesses from ancient Greek mythology. By terrifying contrast, Verrio's painted ceiling above the Hell Staircase shows the mouth of hell as the gaping mouth of a cat with all the souls in torment writhing within. The Great Banqueting Hall is 60ft high, 68ft long and 30ft wide with a soaring double hammer-beam roof fit to grace a cathedral. Descriptions and pictures can barely do any of them justice, it all has to be seen and experienced.

The surrounding park and gardens are on the same vast scale. They extend over 1,400 acres, all of it shaped and landscaped by the great Capability Brown who included a 22-acre lake and a beautiful three-arch, white stone bridge. A more recent addition is the 12-acre sculpture garden where a fascinating array of modern sculptures is assembled by the lakeside. The house and park are in turn the centre of an agricultural estate comprising some 10,000 acres.

The Burghley Horse Trials have been held at Burghley since 1961 when the Marquess of Exeter invited the British Horse Society to bring their major three-day equestrian event to the estate. Since then, Burghley has become a premier international sporting event, hosting two World Championships events

and five European Championships. Princess Anne rides here and won the European Championship in 1971. Her daughter Zara Phillips came second in the championship event of 2003.

The horses and riders, the show-jumping and other competition skills on display, draw vast crowds. Some 140 acres of car parking spaces have to be provided. Up to 7,000 glasses of Pimms and 20,000 bottles of champagne will be consumed. 11,000 baguettes will be eaten. It takes four weeks to prepare the showground and three weeks to clear the site. Statistically everything connected with Burghley seems to be way over the top.

Burghley may be just over the Cambridgeshire border but it is well worth going the extra mile.

CHAPTER THIRTEEN

THE HISTORY
OF THE FENS

Before the glaciers melted at the end of the last Ice Age there was a dry land bridge where woolly mammoth, rhino and giant horned bison roamed between England and Europe. They were preyed upon by lions, bears, wolves and sabre-toothed tigers. The parts of Cambridgeshire that we now know as the Fens were an inland wildwood basin thick with forest just below the edge of the ice sheet. When the ice retreated, the subsequent floods drowned the land bridge and re-shaped England as an island. The rising waters also inundated the low forests of the Fenland. The trees rotted down to form the heavy peat soil that was cut and swamped by intermingled fresh and salt water marshes. As the glacial floodwaters subsided, the misty, half-drowned world of the early fens was created.

It might have seemed that these grim and eerie wetlands were a place where any foolhardy intruder might quickly be lost and vanish forever, swallowed up behind the wet curtains of sedge and reed. The wild, frog-croaking and gull-screaming bogs must have seemed a fearful and dangerous place, full of fog ghosts and night creatures of damp and slime, an environment best avoided, too hostile for humans to survive.

But it was not quite like that. The edges of the Fenland wilderness and those scattered little islands of high ground were a reasonably good place to settle. The plants that grew there provided animal fodder, the abundance of reeds and long grasses provided roofing and woven walls for huts. There were plenty of fish and eels in the creeks and rivers, and the wide ever-changing skies were full of fat wildfowl, geese and ducks and the graceful long-necked swans. All these birds laid eggs that were good to eat. There was plenty of food for anyone who could set a snare, cast a net or fire an arrow.

This is how the first Stone Age inhabitants of the Fens would have lived, mainly by hunting and fishing, penetrating as far as they needed or dared. Then some 3,000 years ago, the first crude weapons and tools of flint and stone were replaced by the advent of the Bronze Age and new cultivation methods came to be learned. The black peat soil of the Fenlands was particularly rich, encouraging farming, and so efforts were made to protect the few small village fields and vegetable patches. Earth banks were constructed to hold back floodwaters and ditches were dug for drainage. The long battle to transform the wet marshes into arable farmland had begun.

When the Romans arrived they built their Fen Causeway to link East Anglia with Middle England, the Causeway ran from what is now Denver in Norfolk to what is now Peterborough in the Upper Nene Valley. They also created road links between Cambridge and Ely. During their 4,000 years of occupation they built more banks to protect the land from the sea and dykes to protect their food crops from the frequently swollen rivers.

During the Dark Ages, after the Roman withdrawal, much of what they had accomplished collapsed. The arrival of the first Christian saints and then the monasteries led to another wave of effort to transform and control the fluctuating water levels of the Fens. The monastic orders were initially attracted by the solitude offered by the lonely and isolated outposts where they choose to build their great abbeys. But the monasteries also needed lands that could raise sheep and crops for their wealth to grow, or to rent to the local populace for the return of their tithes. It was all done for the glory of God, of course, but the hard work of the monks added more defensive banks and drainage ditches, more arable farmlands, and the monasteries grew rich and splendid as their estates expanded.

After the Dissolution of the Monasteries the great estates which had been administered by the monastic orders were claimed by the monarchy, broken up and sold into private hands. More of these rich and fertile farmlands were suddenly in high demand and so the great drainage schemes of the seventeenth century began.

The 1st Earl of Bedford was one of the richest of the new landowners. He had managed to grab the estates of Whittlesey and Thorney abbeys but he wanted more. He gathered together a group of gentlemen – adventure investors as they called themselves – and together they funded an ambitious scheme to turn the heart of the Fenlands into sustainable arable and grazing lands. The project involved digging two huge parallel new rivers diagonally between Earith and Denver. They were to become known as the Old and New Bedford rivers. The cuts were 70ft and 100ft wide and over 20 miles in length.

Bedford hired Dutch engineers led by Cornelius Vermuyden to plan and supervise the work. The lowlands of Holland, with their own perennial flood

problems, had provided the Dutch with long experience. However, the enterprise was not without opposition. Many of the fen dwellers saw their fishing and wildfowling rights and their traditional way of life under threat, and all for the financial gain of a few already rich landlords. They did everything they could to hinder or sabotage the project. It was not unknown for men to work for hire by day and then undo the results of their own labours by night. Their fierce resistance and independence earned them the nickname 'Fen Tigers', a label which still sometimes sticks today, and which Dave 'Boy' Green was proud to wear in the boxing ring.

The construction of the New Bedford Rivers was finally accomplished but it was not the end of the story. The drainage scheme worked too well, the peaty soil dried out and then began to shrink. As the land levels dropped they began to flood again and now the banked up rivers were higher than the land and could no longer drain away the surplus waters. Windmills were introduced in their hundreds, working as drainage pumps to lift water from the fields into the rivers, but because the wind was fickle the pumps often failed to cope. Finally, in the 1820s, steam engines arrived to take over the task and only then did the Fens begin to be effectively drained.

The eighteenth and nineteenth centuries saw more gigantic projects to fight the Fenland floods, and in all it took some 300 years to drain the Fens and win what was literally an uphill struggle to expel the surplus water to the sea.

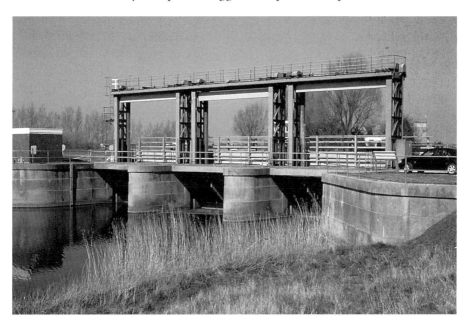

The diversion sluice at Denver.

The Great Ouse Flood Protection Scheme of the mid-1950s cost over £10 million and took ten years. The Fens and the rivers know no county boundaries so the work spread through Cambridgeshire into Norfolk.

Beginning at the great iron and concrete sluices at Denver, where the Old and the New Bedford Rivers drain into the Great Ouse a new relief channel was cut to parallel the remaining course of the main river to the Wash and the sea. In addition to these four main waterways there are three more rivers that meet at or near this Fenland version of a wet spaghetti junction and now there are five great sets of sluice gates here to control the combination of drainage waters and river flow.

The history of the Fens is a testament of man's determination and ingenuity, an ongoing battle over thousands of years which has transferred a wilderness of swamp and marshes into some of the most productive farmlands in England. At least half of the classified grade one agricultural land in the country is here in the rich black soils of the Fens.

The abundance and the variety of the crops produced range from strawberries and apple orchards around Wisbech, vast fields of carrots and celery around Ely and Chatteris, and elsewhere row upon row of fat white cauliflowers, rich green cabbages or Brussels sprouts. This is a vegetable paradise and the Fens as a whole are estimated to contain some 4,000 farms.

The flat landscapes and the seasons are forever changing with bright swathes and flashes of colour from the hosts of flowers that are grown here. The Fenland bulb industry rivals Holland with huge fields of golden daffodils and crimson and yellow tulips. The tiny village of Thriplow celebrates with a Daffodil Festival every spring, and just over the Lincolnshire border the Spalding Flower Parade

The peaceful River Ouse by Denver Sluice.

uses millions of tulips to decorate its annual procession of spectacular floats. Wisbech, of course, has its annual Rose Festival in June. The heady scent of flower blossoms from the magnificent displays in the fields and in the churches are all part of the busy Fenland horticultural calendar.

Modern Cambridgeshire has come a long way from the fearful mist and water world of the Stone Age, but here and there traces still remain and are carefully preserved. In 1981 the National Trust paid just £10 for 0.8 hectares of land at Wicken Fen and today that conservation area has grown to over 500 hectares. Despite some setbacks, such as the wartime government that insisted on draining some of the fen for more food production and a struggle to prevent other parts from being used for bombing practise, Wicken Fen is now the most important surviving area of the once great Fenland of East Anglia.

The four fens at Wicken were helped by their intensive use by the local community and it is mainly the local people, supplemented more recently by willing volunteers, who have managed and worked the fens. Reed and sedge are still harvested for the thatching industry. The reed is used for roofing and the more malleable sedge for the artistic and decorative ridge work. Every thatcher has his own signature in the detail of the ridge design.

Regular harvesting of the sedge and fen hay encourages a huge diversity of wild flowers and literally thousands of different insects. Many species of dragonfly and red-eyed and emerald damselflies hover and buzz over the waving

Wicken Fen, woodland and water.

plains of reed and grasses on the hot days of mid-summer. Moths and butterflies add to the flutters of colour and movement. Kingfishers, reed warblers and swans are among the multitude of birds to be found along the networks of lodes, ditches and drains. Nightingales sing in the woods, woodpeckers rattle and tap, tawny owls hoot and call while hen and marsh harriers swoop and dive in their low patrols for small rodents. Yellow and white water lilies add to the heady array of wild violets, orchids, parsley, meadowsweet and fields of red flowering meadow thistles.

It is all the result of careful and loving conservation so it is still far from the original untamed wilderness. Nevertheless it preserves all the diversity of the Fens and the fen flora and fauna of yesteryear. There is a fenman's cottage restored with traditional methods and materials, which provides a snapshot of life as it would have been at the start of the twentieth century. The traditional tools for harvesting the sedge and reeds, digging peat, shooting and trapping of wildfowl, trapping eels and fishing are all dutifully preserved.

The focal point of Wicken Fen is the old black, white-sailed, twelve-sided smock windmill, one of the last surviving windpumps of the thousands which once operated in the Fens. It is now smartly painted and restored to full working order, although it is rarely used because of a tendency to flood the visitor route. The windpump is prominent in almost all the literature describing Wicken Fen, the photographs show it in high summer looking down the blue ribbon of the dyke against a backdrop of brilliant blue sky, in autumn when it is surrounded by a sea of golden reed and grass, and in winter when the sails and everything that frames them are heaped with fresh snow or dripping with white hoar frost.

Left: Wicken Fen windpump.

Below: Bronze Age hut at Flag Fen.

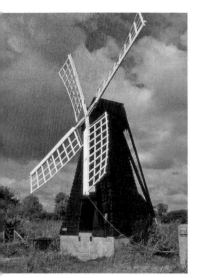

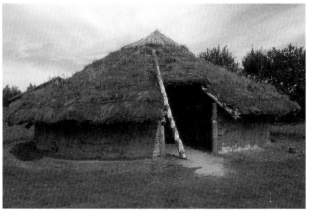

Wicken Fen is now one of Cambridgeshire's two premier fen visitor sites. The other is Flag Fen which has been briefly mentioned in passing as we travelled down the course of the Nene. Flag Fen is renowned as Britain's most important Bronze Age centre, its insights going back 3,000 years into the dim and mysterious past.

The story begins back in 1982 when a mechanical digger clearing one of the fen drainage ditches pulled out some very unusual ancient timbers. The timbers were sent for radiocarbon dating and proved to date back to 1000 BC. The subsequent archaeological digs at the site have uncovered evidence of five rows of posts that formed an enormous palisade flanking a giant timber platform the size of a football stadium. The platform appears to have been an artificial island in a lake, linked by a causeway to both shores. It must have been a monumental undertaking for the people and technology of the time, perhaps a memorial to the ancestors of our ancestors and almost certainly of some communal religious significance.

There were 60,000 of these posts and the five rows were at least a kilometre in length. From the surrounding mud and waters jewellery and broken daggers have been retrieved in sufficient numbers to suggest that these were offerings cast into the lake to appease the gods. It is possible that this was one of the periods when high tides and rising floodwaters were threatening to overwhelm the community and the gods were seen to be angry.

Today there is a new Millennium Centre here displaying all the known aspects of Bronze Age life. Many of the post remains can be viewed in an undercover display hall which also includes a 60m wall painting showing how it is believed that the villagers would have lived here in the Fens 3,000 years ago. The 20-acre park also contains reconstructions of the circular, grass-roofed huts of the Bronze and Iron ages.

The site has survived and the timbers were preserved by the fact that everything here was heavily waterlogged and under mud and marsh. Now it is drying out and so the archaeological work continues to learn and salvage as much as possible before it is lost.

Deer skull totem inside one of the Flag Fen huts.

In addition to these two superb sites dedicated to preserving the past heritage of the Fens, Cambridgeshire also has numerous nature reserves where wildlife and their habitats are safeguarded for the future. Ducks, geese and swans are no longer on the daily fenland menu but the wildfowl are still there in their millions to provide awesome spectacles of natural wonder on the wetlands.

The Welney Wildfowl and Wetlands Centre is located on the Norfolk border close to the New Bedford River, and covers 1,000 acres of the Ouse Washes. Spring is the breeding season, the balmy air full of the hum of bees and dragonflies, butterflies and moths, the sounds of songbirds and the cries of the waders, the avocets, redshank and lapwing. Summer sees a profusion of wildflowers and rushes around the bustling lagoons. Swallows and house martins join the owls and hawks hunting overhead as mallard, teal and goldeneye ducks glide on the sparkling waters. Autumn sees the colours change to tints of bronze and gold. All through the year there is wildfowl activity to watch from the many small hides and the main viewing gallery. However, it is in winter that the reserve sees mass gathering of thousands of ducks, geese and the magnificent whooper and Berwick swans which migrate south from the frozen Arctic.

The days are short in January but then the lagoons in front of the viewing gallery with its wide, high windows are all floodlit when the swans are fed. Members of the centre staff push out wheelbarrows of feed and shovel it out to the waiting birds which fill the lagoons and the sky. When the snow is falling at the same time the effect is magical, a living world of swirling white wings and drifting fluffy flakes. Ice bejewels the surrounding reeds and grasses and everywhere sparkles and glitters. The swan necks form a graceful forest of white bobbing masts to the feathered white sailing ships of the swan bodies. It truly is a winter wonderland.

All of this plus a splendid network of walks and waterways help to make the Cambridgeshire Fens a magnet for visitors and tourists, for birdwatchers and small boat sailors. Anglers will find the many rivers and dykes filled with roach, bream, pike, eels and sporting zander. The Fenlands are generally flat but they are never boring. There is an amazing diversity of things to see and do under those high, wide cloudscapes.

CHAPTER FIFTEEN

WAR OVER CAMBRIDGESHIRE

During the Second World War every county in the east of England was filled to capacity with military aircraft, the Hurricane and Spitfire fighters of the RAF, the Mustangs, Lightnings and Thunderbolts of the USAF, and the heavy bombers, the RAF Wellingtons and Lancasters, American Liberators, Marauders and the famous Flying Fortress. Existing airfields were expanded and new airfields and satellite airfields were hastily built. There were a score of airfields operating in Cambridgeshire, with millions of young English and American pilots and aircrews fighting the Battle of Britain and then paving the way for the re-conquest of Nazi-occupied Europe. Hundreds of thousands were shot down, crashed and died.

The airfields were so thick on the ground that some of them were only a few miles apart. The airfields at Bassingbourn and Steeple Morden had only 3 miles between them.

The men who arrived to fly the aircraft came from all over the globe. RAF Bourn was practically a flying Commonwealth with men of the Royal Air Force, the Royal Canadian Air Force, the Royal Australian Air Force, the Royal New Zealand Air Force, the Royal Jamaican Air Force and the Royal West Indian Air Force. Other airfields hosted Czechoslovakian, Dutch, Free French and Polish pilots, all fighting to free their lost homelands.

Bourn, 8 miles east of Cambridge, was one of the new airfields constructed for Bomber Command in 1940 as a satellite for RAF Oakington. The station had its share of disasters. It received four bombing raids from the Junkers of the Luftwaffe but the worst night of all came in December 1943 when a task force of twenty-one Lancaster bombers took part in a raid on Berlin. One Lancaster was shot down over the target, killing all seven of its crew. The rest of the flight struggled home to

The Vickers Supermarine Spitfire.

find the whole of Cambridgeshire swamped in thick fog. Many of the aircraft were damaged and all were short of fuel. In the murk, eight of the Lancasters crashed in the woods and fields around the airfield they failed to find.

Bourn flew Wellingtons, Lancasters, Stirlings and later Mosquitoes and in 1944 became home to one of the new Pathfinder squadrons. The Pathfinders were the top bomb crews of the RAF and their task was to fly in ahead of the main bomber force and mark the designated targets with their own bomb loads and target indicators.

By the time the last sortie had been flown in April 1945 Bourn had lost 164 aircraft with 622 aircrew killed in action.

Like Bourn every airfield has its history of heroism and horror, of the fighter squadrons who threw back the might of the Luftwaffe, and the bomber crews who flew the nightly hell runs into Europe to pound the Nazi infrastructure into collapse. Here we can only look at a few, but this does nothing to detract from the glorious fighting spirit of them all.

The airfield at Mepal, 6 miles east of Ely, was home to No. 75 New Zealand Squadron, flying Short Stirling Bombers and later Lancasters. The squadron flew a staggering 8,017 sorties, the highest squadron total for the whole of RAF Bomber Command. These comprised 739 flight operations and losses of 193 aircraft.

After the war, Mepal continued with a high profile in the Cold War that followed. As tensions heightened between the Soviet Union and the West a new phase of nuclear and ballistic missile warfare was envisaged. Mepal became a base for Thor missiles. Three massive concrete launch pads were constructed and

the rockets were flown in by huge USAF Globemaster military cargo planes. The base became operational in July 1959. Their presence put the placid heart of Cambridgeshire in the front line of any potential missile exchange between East and West and caused much public concern and unrest. Mercifully they were never used and became obsolete in 1963. Now, like so many of the old wartime airfields the land has been returned to agricultural and commercial use. The peaceful drone of a ploughing tractor has replaced the chanting of protestors and the roar of heavy bombers.

Alconbury near Huntingdon was one of the first airfields to be occupied by the USAF when the might of America pitched in to join the air war. The airfield was constructed in 1938 and used by RAF Bomber Command until May of 1942 when it was allocated to the US Eighth Air Force. The US 93rd Bomb Group moved in flying Liberator bombers. They began with attacking steel engineering works in France and the submarine pens along the Bay of Biscay coast.

In January 1943 the 93rd was replaced by the 92nd Bomb Group and the Liberators at Alconbury were replaced by the magnificent B-17s, the Flying Fortress with its swivelling top and bottom ball machine-gun turrets. They continued bombing strategic targets which included shipyards, submarine installations and anything that promoted the German war effort. The 95th came next and their targets included the German V rocket installations that were beginning to terrify London.

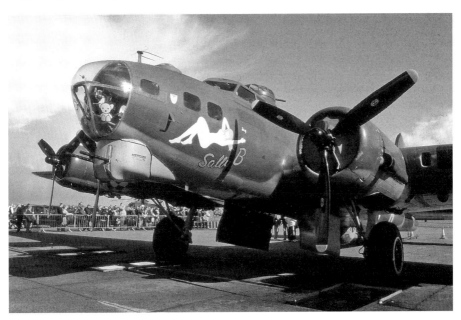

The Sally B Flying Fortress.

A black day for Alconbury came on 27 May 1943, when a 500-pound bomb accidentally detonated while being loaded and armed onto a B-17. The explosion caused a chain reaction as several more bombs detonated. In all, eighteen personnel were killed and twenty-one were injured. Four B-17s were destroyed in the inferno and eleven others severely damaged.

Alconbury also played a key role in the clandestine night flights which supported the dangerous activities of the Special Operations Executive. For these tasks specially adapted Liberators were used, all unnecessary lights were blacked out and the fuselage underbellies were painted black to avoid being picked out by enemy searchlights. SOE agents, supplies, arms and everything needed to support the French resistance forces were dropped by parachute into occupied territory. Combat was avoided wherever possible and after making their drop the pilots would continue to fly on over enemy lines so that their turnaround point could not be marked as the drop zone.

Combat operations ended with the end of the war but the Americans stayed. As the Cold War tensions rose with the Berlin Blockade and then the Korean War a strong American presence in Britain was seen as essential to world peace and in 1951 RAF Alconbury was again allocated for American use. A major expansion was needed with the upgrading and extending of the runways.

Most of the old wartime airfields have faded into memory and history but one still remains vibrantly alive. Duxford, just south of Cambridge, off Junction 10 of the M11, has been taken over by the Imperial War Museum and developed into one of the most magnificent collections of aircraft and wartime memorabilia in the country.

Duxford has served through both world wars. The aerodrome was constructed at the beginning of the First World War, initially as a training station for the Royal Flying Corps but even before it was finished it became home for three squadrons of bombers.

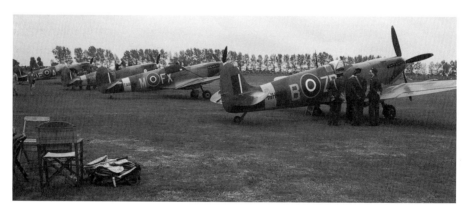

Spitfires on parade.

In 1924 Duxford became a fighter station and one of the first to receive the new Supermarine Spitfires which with the Hawker Hurricanes became the key fighters in winning the Battle of Britain. In those dark days of the 1940s when Hitler tried to crush England into submission with the might of his Luftwaffe it was only the valiant few who stood between the Nazis and victory. The pilots on stand-by at Duxford were called upon again and again to take to the skies and intercept the fleets of heavy German bombers heading for London.

Their invincible courage and the bulldog spirit that infused them all, shines clearly through the example of Squadron Leader Douglas Bader, a man who had already lost both his legs in an earlier air crash. Bader was determined to fly again, despite his artificial limbs. At Duxford the legless ace led squadrons 9 and 310 in a Big Wing, a mix of some sixty Spitfires and Hurricanes whose pilots lived in constant readiness to 'Scramble'.

The call to action, the 'Scramble' to get the planes into the air, happened on a daily basis, but some days were more successful than others. On 9 September 1940 the Duxford squadrons successfully intercepted and turned back a larger force of German bombers before they could reach London. On 12 December they took to the air twice, and twice they repulsed and threw back the enemy.

The Duxford squadrons played a vital role in winning the Battle of Britain but once the tide had turned the role of the station changed. In April 1943 the airfield was handed over to the US Eighth Air Force. The task now was not defending London but carrying the war to the enemy and attacking Germany. Duxford became the headquarters of the USAF 78th fighter group flying Thunderbolts to act as fighter escort to the great waves of USAF bombers that were now pounding occupied Europe and the German homeland.

At the end of the war Duxford was handed back to the RAF. By 1969 the airfield was considered redundant and the Ministry of Defence decided to dispose of it. By this time the Imperial War Museum in London had found that its collections were fast outgrowing their space and they needed somewhere new to store and display their exhibits. Duxford was the ideal answer. In 1977 the museum joined with Cambridgeshire County Council and the Duxford Aviation Society to purchase the old aerodrome and give Duxford a new lease of life.

Today, Duxford is Europe's premier aviation and heritage complex. Its five great hangars house spectacular collections. In Hangar One there are thirty classic, British and Commonwealth, aircraft, parked or suspended from the ceiling. They form the Air Space Exhibition which tells the story of British aviation from the early days of tiny, open cockpit bi-planes to modern supersonic jets. Hangar Two houses an incredible Fighter collection. Hangar Three displays a collection of naval memorabilia which includes a miniature submarine in addition to Fleet

Air Arm aircraft. Hangar Four houses the Battle of Britain Exhibition while Hangar Five is the conservation area where all the renovation work is done.

A specially built Land Warfare Hall showcases the Normandy landings with tableau's and tanks and armoured cars, and also tells the histories of the Royal Anglian and the Cambridgeshire regiments. The Cambridgeshire Regiment was formed in 1860 as the Cambridgeshire Rifle Volunteer Corps and was finally amalgamated into D Company of the 6th Volunteer Battalion of the Royal Anglian Regiment.

Another recent addition is the splendid sweeping arch and dome of the American Air Museum, an impressive curvature of modern architecture which is home to the largest and finest collection of historical American combat aircraft outside the United States. The great dome is filled with aircraft from floor to ceiling, including the SR-71 Blackbird, the U-2 spy plane, a restored B-24 Liberator, and a Giant B-29 Superfortress, a sister bomber to the one which dropped that first fateful Atomic Bomb on the Japanese city of Hiroshima, the act which ended the Second World War.

The airfield hosts regular air shows with fantastic flying displays from its resident and visiting aircraft, including the magnificent Red Arrows. The Sally-B, Duxford's resident B-17 Flying Fortress, will fly again and the grand finale is always a Battle of Britain tribute flight from the last flyable Lancaster escorted by a brace of cocky little Spitfires.

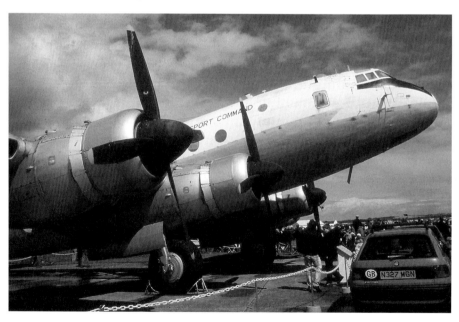

Duxford Air Show.

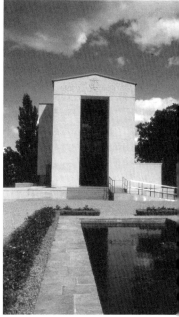

Above: The Memorial Hall and chapel at the American War
Cemetery at Madingley.
Right: The American War Cemetery at Madingley.

Not far from Duxford, at Madingley on the eastern edge of the city of
Cambridge, is one more poignant reminder of the great aerial conflict of the
Second World War. The Cambridge American Cemetery and Memorial is a
30-acre site with over 3,000 graves.

The memorial is reminiscent of the Abraham Lincoln Memorial in
Washington, a simple square building of white Portland stone with a frontage of
five massive square pillars. Inside is a battle map on the facing wall, showing the
aerial sorties from East Anglia. The ceiling has a mosaic of ghostly aircraft and
angels. At the east end is a small chapel. A bronze inscription above the chapel
door reads, 'Into Thy Hands, O God'. Above the memorial are carved the words,
'O Lord, Grant Them Eternal Rest'.

The memorial is approached by a long mall with three long, calm, reflecting
pools. At the entrance end stands a 72ft-high flagpole flying the Stars and Stripes.
Along one side of the mall there runs a 427ft-long, 12ft-high wall, again of white
Portland stone, engraved with 5,127 names. These are the Tablets of the Missing,
the men who were lost but their bodies never recovered for burial.

Laid out like a great white fan, the flagpole being the pivot point and the mall
its right-hand edge, is the cemetery. The rows and rows of simple white stone
crosses form sweeping curves that blur together in one vast sad but noble image.

Today the skies above Cambridgeshire are peaceful, blue and free and for that
we must thank the brave pilots of the RAF, the USAF, and all our friends from
across the seas.

CHAPTER FIFTEEN

NEWMARKET

Again we are stretching the boundaries a little but the cartographers who drew the Suffolk/Cambridgeshire county line took a little bite out of Cambridgeshire to include this charming Suffolk town which is only 15 miles down the A14 from the city of Cambridge. In Edwardian times, before the latest boundary changes were made, the town was actually recorded as being in Cambridgeshire so it is only an arbitrary line after all. In any case, having come so close most visitors to Cambridgeshire would probably not want to miss out on a visit to the horse-racing capital of the world, and so this guide is happy to provide a taster.

Newmarket lives, breathes, works and thrives around the flamboyant world of horse racing. Its heroes are its jockeys riding high and proud in their colourful racing silks and its lifeblood flows in the veins of its prancing thoroughbreds. Horses dominate the town and at one stage were regarded as more important than people. It was even against the law to blow your nose in the street. Anyone caught outside their house with a head cold was liable to a fine. This was not for the benefit of other human beings but to protect the much more valuable horses.

So it is no surprise that Newmarket has always been just a little bit horse crazy, ever since Queen Boudicca set up a stud at nearby Exning way back in the Roman Age. No doubt the wide open spaces of heathland were as perfect for racing chariots then, as they are for exercising the thousands of thoroughbreds that gallop here today.

As you enter Newmarket from the west there is a superb black bronze statue of a rearing stallion in the centre of the large roundabout on the A1304. It is a life-size equestrian poem in motion, and on a fine sunny day with a little heat haze you can almost see the sleek flank muscles ripple and the flared nostrils snorting. It is a fitting landmark for a town that is famous as the headquarters of British racing.

Try to drive through Newmarket at the crack of dawn and you will find the traffic backed up to let strings of fifty or more racehorses cross the road in long processions from more than fifty stables to the gallops. There are over 2,500 horses in training here, and on any morning, wet or fine, you can see most of them walking, trotting, or flying at full gallop between the 20 miles or more of white fencing that marks out the walkways and the courses.

Newmarket first appeared as a developing town around the year 1200. There were springs and a small stream here and the land was tilled by a few tenant farmers. A Norman knight named Richard de Argentein married the daughter of the lord of nearby Exning and was given the land as a dowry. Sir Richard obviously had some influence in the Royal Court and was able to acquire a charter from Henry III to establish a new market, and so the town of Newmarket was born.

It was in the seventeenth century that King James I discovered the equestrian pleasures of Newmarket, first to indulge in his passion for hare-hunting on the heath and then to enjoy the racing. The first recorded race was run in 1622. It was a two-horse race between horses belonging to Lord Salisbury and the Marquis of Buckingham. The wager was for £30, which was an enormous sum at the time. Buckingham's horse won and it was the beginning of the entire history of thundering hooves, screaming excitement and the joy or despair of fortunes being lost or won.

Charles I and then Charles II, famously known as the 'Merry Monarch', continued the royal passion for the sporting pleasures of the turf. Charles II was a keen rider who moved his court into Newmarket every summer for the

racing season. He built Palace House as his second home and for a while Newmarket was even known as the unofficial second capital of England.

The first race ever to be run under written rules was the Town Plate Race, which first took place in 1666. Charles had created the race by a decree in Parliament the previous year and rode his own horse to victory in the race of 1671. The race is still run at Newmarket every year and is the oldest surviving official horse race.

The rearing stallion, the symbol of Newmarket.

Horse racing has been the sport of kings and queens ever since. At one stage, during the English Civil War, Newmarket was suspected of being a cover for Royalist sympathies and disaffection. It was a fair enough assumption but with most of Cambridgeshire solidly behind Cromwell and his Roundheads the Royalists at Newmarket were probably wise to keep quiet and to keep their heads down.

The town has two major racecourses, the Rowley Mile Course and the July Course. The first is named after Old Rowley, a racehorse owned by Charles II, and was established by the Merry Monarch when he discovered that at the beginning and end of the racing season on the July Course the sun was in his eyes. Creating a second racecourse at a different angle was the obvious answer.

The Rowley Mile is still the racing venue for spring and autumn and the action shifts to the July Course for the intervening summer season. In fact the races shift from one county to another because the Rowley Course is in Suffolk while the July Course is in Cambridgeshire. We really are on the edge here. In between the two is Devil's Dyke, the great early Saxon earthwork that stretches for over 7 miles from Woodditton in Suffolk to the small village of Reach in Cambridgeshire. It forms a long grassy finger pointing you back toward the Fens.

The Devil's Dyke once formed part of the Iceni border of East Anglia. Archaeological research suggests that it was probably built on top of an even earlier Bronze Age rampart. In those past ages Reach would have marked the beginning of the marshes while south of Woodditton would have been almost impenetrable forest. The earth wall, still 30ft high in places, follows a chalk ridge between the two and would have proved a defensible barrier.

Three ancient Roman roads crossed the dyke, including the Icknield Way, so the Romans would have strengthened it to maintain their control over trade and movement throughout the area. Today a number of modern roads and rail tracks cut through the dyke but there is still a path along the top that enables walkers to walk the whole distance with endless flat views of the fields and sheep pastures all around.

Back at Newmarket the history of horse racing continued to flow on either side of the Devil's Dyke. In 1750 it became the obvious place to establish the headquarters of the Jockey Club. The elite members of the English horse-racing scene met here to form the club and establish and supervise the rules and regulations to control the sport which was growing fast in popularity. They also sanctioned more racecourses to hold meetings under their rules and now control fourteen racecourses throughout the country.

The Jockey Club also operates the National Stud which focuses on breeding thoroughbred horses. It is the largest shareholder in the Racecourse Media Group and is the largest commercial grouping in British horse racing and the leading investor and innovating force in the sport as a whole.

Devil's Dyke.

The Jockey Club moved to London in the 1960s but the magnificent Jockey Club rooms can still be found halfway down the High Street. Marking the spot is another perfectly formed horse statue on a pedestal, that of the champion racehorse Hyperion.

The prize money on offer became a major spur to the growth of the 'Sport of Kings'. In 1809 the Jockey Club inaugurated the 2,000 Guineas Race, which is still the first classic race of the British racing season. Five years later the 1,000 Guineas was raced for the first time. The Cambridgeshire and the Cesarewitch, the two great handicap races which make up the Autumn Double came in 1839. In 1887 the Champion stakes were inaugurated making Champion's Day the highest-class race meeting in the country.

Practically every innovation in horse racing first appeared at Newmarket. In 1949 the first photo-finish camera arrived to end forever the arguments over which set of horse nostrils was the first to flash past the winning post. In 1965 the first starting stalls were put in place to ensure that no jockey could actually jump the starting gun. Now the moment when the gates burst open to let the horses fly forward is second in excitement only to the moment when the first horse reaches the finish.

The railway arrived in 1846 and marked the transition from one era to another. Newmarket Heath had become notorious for its lurking highwaymen and footpads. The robbers laid in ambush for the rich gentlemen travelling to the races with money to gamble in their pockets, or with their winnings coming home. At one point there had even been calls for armed guards to be put on the passing mail coaches, rather like the idea of riding shotgun in the Old West. It never actually happened and the coming of the railways put an end to mail coaches and highwaymen together.

The hissing, puffing steam trains also changed the nature of the race meetings. Previously they had been mainly for the pleasure of royalty and the rich. The presence of the lower classes had never been really encouraged. Now the trains meant that people of all levels and from all over the country could flock to Newmarket to enjoy a flutter on the horses. Victorian Newmarket thrived as never before and racing was transformed for the masses. It is now the second most popular spectator sport in England after football.

The main landmark of Newmarket today is the handsome red and white brick Jubilee Clock Tower which overlooks the roundabout at the east end of the town. The High Street was once the main road from Norwich to London before the bypass of the A14 was built. Today it is almost as busy again with modern traffic and is now flanked with modern shops in addition to well-established banks and hotels.

On the left as you head down the street is the National Horse Racing Museum occupying the old Subscription Rooms. Here in the nineteenth century the rich gentry would meet to place their wagers and again after the racing. Outside the crowds of common folk would wait, anxious to learn which horses were being heavily backed. It was the original way of picking out the favourites. Today the museum is the best place to see all the old racing prints and photos, the Munnings paintings and all the memorabilia and to learn all the rich and colourful history of the sport and the town.

Next along the High Street comes the Jockey Club and on the right the red-brick, high-gable façade of the old King Edward Grammar School that is now the council offices. Beside the grammar school is the curved red

Left: Newmarket's Jubilee Clock.
Below: Newmarket High Street.

Newmarket, the Doric Cinema and the old King Edward Grammar School.

and white frontage of the old Doric Cinema which is now a Bingo Hall. In summer there is a profusion of flower boxes filled with red geraniums and endless hanging flower baskets adding bright splashes of colour all along the street.

In the summer of 2011 the town went even more colour crazy with a display of a score of life-sized fibreglass horses which were the high profile, highly visible results of a community art event promoted by Newmarket Town Council. Following a competition, thirteen artists were selected to paint their pictures on these smooth-lacquered, life-sized model horses, basing their designs on the names of past winners of the celebrated 2,000 Guineas Race. When completed the horses were placed in strategic positions all around the town to form a Horse about Newmarket Walking Trail.

The real racehorses avoid the High Street but can often be seen moving through the leafy avenues and suburbs on either side. Here you will also find Newmarket's two main town centre churches. There are actually eight churches in Newmarket but the tall spire-topped tower of the parish church of St Mary's is the most high profile, sitting on the Suffolk side of the High Street not far from the market. It was built on the site of a mediaeval chapel and was updated in Victorian times. All Saints' church is on the Cambridgeshire side of the High Street and was in fact once in Cambridgeshire, another reminder that Newmarket is on the edge of a shifting boundary.

Horses riding past
St Mary's church.

Newmarket is a pleasant enough place to visit, with a Saturday market and a new Guineas shopping mall to draw in the visitors, but everything in Newmarket revolves around the racing. To get the full flavour of this unique little town it is essential to go to the races. The Rowley Mile Course is now overlooked by a superb £21 million modern grandstand and the atmosphere at any race meeting is fantastic. The very air is electric as the jockeys parade their magnificent mounts in a mounted rainbow of brilliantly coloured racing silks. The gambling fever rises as the bets are placed. The crack of the starting gun, the explosion of horses as the starting gates burst open, the thunder of hooves on turf, the roar of the crowd; it all has the intensive thrill that can only be felt by actually being there.

Place your bets, win or lose it hardly matters. Just feel and live the world of racing and you will understand the magnetism that has made it the 'Sport of Kings'.

CHAPTER SIXTEEN

THE UNIVERSITY CITY

We have visited Cambridge on our journey down the River Cam, passing along the backs of the colleges, but now it is time to take a closer look at this magnificent university city. Its stunning collection of colleges and pinnacles of higher learning make Cambridge into one of the foremost assemblies of classical architecture to be found anywhere in Europe. There are nearly thirty towns named after Cambridge scattered around the globe but all of them are but pale imitations of the glorious original.

The traces of human settlement in the area go back long before the arrival of the Romans. The first known place of occupation was a 3,500-year-old farmstead which was found at the site of the Fitzwilliam College. Later, sometime around the first century BC, an Iron Age tribe is known to have settled on what is now Castle Hill. In those days this would have been where the thick forest to the south gave way to the trackless marshes of the north. The river was probably the dividing line and the spot where Cambridge stands would have provided the all-important fording place.

When the Romans arrived they immediately saw the potential for a military outpost on Castle Hill. The ford became the crossing point for the Via Devana, the new Roman road which linked the main Roman power base at Colchester to the south with the out-flung Roman garrisons in the Upper Nene Valley and Lincoln to the north. Under Roman occupation the new settlement quickly grew into a regional centre and a bridge was established over the river. The Roman name for their new town was Duroliponte, which means bridge over water.

When the Romans left the local Saxons decided to change the name. Duroliponte became Grantabrycge, or the bridge over the Granta. Over time it was decided that where the Grant and the Cam came together the main river was the Cam and so Grantabridge eventually became Cambridge.

There are bicycles everywhere in Cambridge.

The Saxon town continued to benefit from its prime position on the trade link through the misty Fenlands. The Vikings came and imposed the Danelaw and after the initial rape and plunder their vigorous trading practises again helped the town to prosper. When the Viking period waned the Saxons reclaimed their town but only until the arrival of the Normans in 1066. In 1088 the Norman Castle was built on the favoured conqueror's vantage point of Castle Hill.

The story of Cambridge as a university city actually begins at Oxford. In 1167 King Henry II quarrelled with his archbishop Thomas à Becket over the conflicting rights of the Church and the Crown. Becket was later murdered by four of Henry's knights in Canterbury Cathedral but one of the earlier consequences of their disagreement was that Henry had banned English scholars from studying in France. With no access to the university at Paris, English scholars and academics began to cluster in Oxford. Eventually their numbers grew to the point where the town could hardly feed them all and the inevitable tensions between town and gown began to arise.

In the year 1209 the Oxford pot boiled over when three of the students were involved in the killing of a local woman. The angry townsfolk formed a mob to hunt them down and hanged them, apparently with the blessing of the new King John who was preoccupied with other matters at the time and allowed them to get on with it. Many of Oxford's overcrowded students fled

the town at this point and many of them with some of their tutors ended up in Cambridge. In 1284, Peterhouse College, the first of the many colleges in Cambridge, was founded.

England now had two great university cities developing side by side, competing in prestige and achievement in an academic rivalry that culminates in the annual Oxford and Cambridge Boat Race. Two crews of rowing eights, the light blues of Cambridge and the dark blues of Oxford, battle it out on a 4-mile stretch of the Thames upstream between Putney and Mortlake. The coxes compete to find the fastest flow of current which is in the centre and deepest part of the river, and often leads to a clash of oar blades.

Wind conditions and tide speed can lead to very rough waters but it is a tradition that the race is never cancelled. On several occasions one or both boats have been swamped and sunk and in the case of both boats sinking the race will have to be re-run. Up to a quarter of a million people have watched the boat race live from both banks of the Thames and millions more watch it on television. The race has become one of the major fixtures of the British sporting calendar.

One Norman building which still survives the passage of time in Cambridge is the Round Church of the Holy Sepulchre at the junction of St John's Street and Bridge Street. Unmistakeable with its pointed cone roof, this is one of only four circular churches to be built in England and the architectural form was almost certainly brought back by the early crusaders who had visited the original in Jerusalem.

Looking right down Bridge Street is St Stephen's church and then a stretch of lovely old Tudor and Jacobean shop fronts just before Magdalene Bridge. Here a fleet of polished brown wooden punts has replaced the old trading barges that would have stopped here in the Middle Ages. Beyond the bridge is Magdalene College which was founded by Henry VIII's Lord Chancellor in 1542. It was the last all-male college which did not concede to admitting women until 1988.

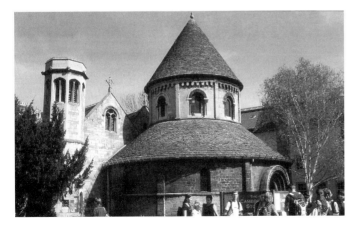

The Round
Church of the
Holy Sepulchre.

Opposite the round church is the entrance to St John's Street and the impressive red-brick Tudor tower gateway into the first court of St John's College. The college was founded in 1511 by Lady Margaret Beaufort, the mother of Henry VII. This is where the Oxford and Cambridge Boat Race began in 1829 when St John's challenged Oxford to the first race. All over Cambridge there are glimpses through mediaeval, porter-guarded gateways into these hallowed courtyards, some cobbled, some paved and some green with turf. They are brief impressions of the peaceful, private world of learning.

The next great college is Trinity with another magnificent four-turret square tower, red and white brick Tudor gateway. Appropriately enough St John's Street has now become Trinity Street. This is the largest and wealthiest college in Cambridge, founded by Henry VIII in 1546. Its Great Court of 2 acres of manicured lawn with a splendid cupola fountain in the centre is claimed to be the largest university court in the world. Isaac Newton studied here, as did the poets Byron and Tennyson, and more recently the current Prince of Wales, Prince Charles.

Still in Trinity Street is Gonville and Caius College which was first established by Edmund Gonville in 1348. It was the fourth Cambridge College. Gonville Hall struggled financially until it was re-founded by John Caius in 1557. Since then it has been Gonville and Caius, usually pronounced as 'Kees'. Another extremely successful and wealthy college it has given the world no less than twelve Nobel Prize winners.

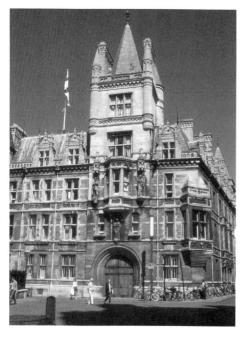

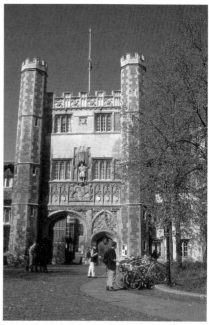

Trinity College.

Gonville and Caius College.

Moving on to where Trinity Street becomes King's Parade stands the Senate House, built in 1720 and looking like some huge colonnade temple transplanted from classical Greece. The Senate House is the university parliament which frames its rules and confers honorary degrees.

Here the road opens out to give a long view of the many pinnacled ramparts of King's College, founded by King Henry VI in 1441. The walls have pinnacles, the great doorway of the Porter's Lodge is topped by even higher pinnacles, and the soaring pinnacles of the King's College chapel behind the wall on the north side of the huge courtyard rise even higher still. The whole is an architectural Gothic extravaganza of low to lofty cross-topped spires.

The chapel has been ranked as the most beautiful building in Cambridge and the interior is even more awe-inspiring. There are twenty-six tall windows containing what has been described as the finest surviving range of pre-Reformation stained glass in the country. There are exquisite heraldic stone sculptures and an intricately carved wooden organ screen which was a gift from Henry VIII when he married Anne Boleyn. The chapel contains a Reubens masterpiece showing the adoration of the Magi, and overall spreads a breathtaking fan-vaulted roof. To listen to a service here is a magical and deeply spiritual experience and its annual Festival of Nine Lessons and Carols is broadcast to the world on every Christmas Eve.

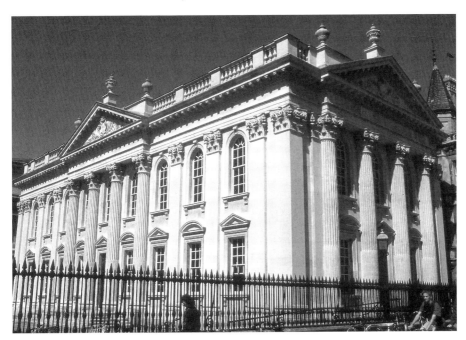

The Senate House.

Opposite King's College is Great St Mary's church. In a city with many beautiful churches this is the university church. It is a handsome fifteenth-century flint building with a seventeenth-century tower. The church faces onto the Market Hill where the fruit and vegetable and general market is still held on every day of the week, with an additional arts crafts and antiques market on Sundays. From the top of the church tower there are fine views over the town and the surrounding countryside.

King's Parade passes between St Catherine's College and Corpus Christi and passes Pembroke Street leading up to Pembroke College before making yet another name change. Now it has become Trumpington Street. Here you will find the Fitzwilliam Museum with its massive Grecian portico of high Doric columns and decorated gable end. The interior is a maze of glass display cases and a décor of mosaics and coloured marble. Its collections of Classical, Egyptian and Oriental art are world renowned and this is the largest and most magnificent of all the fascinating museums in Cambridge.

Keep following Trumpington Road and you will eventually come to the University Botanical Gardens. Established in 1762 they are rated second only to Kew Gardens in London in terms of national importance. The wide range of flower beds, lawns, ponds and rockeries make a pleasant and peaceful interlude with nature after the bustle of the city and the mind-dazzling array of its incomparable architecture.

Moving further east, away from the river and the colleges are the shopping centres, the ultra-modern Grafton Centre and Lion Yard cater for the serious shoppers looking for big name stores and boutiques. Major bookstores stock every necessary text book, and small side alley antique and second-hand book shops cater for browsers in search of a hidden first edition or a literary gem.

Then there are the wide open spaces of Parker's Piece, Christ's Pieces, Jesus Green and Midsummer Common. These are the green lungs of the city where people flock in summer to picnic and play, eat their sandwiches and read books.

Cambridge is a city of learning, overflowing with churches and colleges and other monuments from the past, but it also has its gaze firmly fixed into the future. On the northern edge of the city is the Cambridge Science Park, a modern industrial estate of futuristic designed facilities dedicated to the support of high-tech businesses and so called technology incubators. Napp Pharmaceuticals is located here together with Microsoft Research UK and many other computer and telecommunications research and development firms. The park has been nicknamed Silicone Fen in reference to its likeness to Silicone Valley in California. One technical consulting firm has even called itself Futureneering Ltd.

Taking one step further into the future and listening far into the outer reaches of space are the arrayed ranges of the Mullard Radio Astronomy Observatory at Lord's Bridge just to the west of Cambridge. Here there are rows and circles of large parabolic dishes and what look like giant futuristic TV aerials, some of them mobile along the tracks of an abandoned railway line, all searching the heavens for a greater understanding of the universe to which we belong. It has been discovered that an array of linked dishes or aerials all engaged in the same task works better than one large single dish or aerial and this technique has been pioneered at Cambridge.

The systems gather information on our own solar system, the stars of the Milky Way and the far-flung galaxies beyond. Radio waves can be detected from the most remote corners of the universe, some of them originating far back in time from the cosmic radiation left over from birth of the Big Bang. They allow scientists and their computers to analyse data on everything from star formation, the nature of pulsars and quasars and even the evolution of the universe itself. Here the pursuit of pure knowledge strives to bring everything together.

However, the heart of Cambridge will always be that of a university city. It has an atmosphere of youthful zest and vigour. Students flash past on bicycles with college scarves flying. Everywhere there are leaning racks of chained bicycles to be navigated along the pavements. The railings around St Mary's church act as the university notice board, fluttering with flyers advertising the latest pop gig, jazz venue or poetry recital. The packed coffee shops, cosy pubs, restaurants and bars are full of conversation buzz in a score of different languages. The nightlife is vibrant and there is live theatre at the old Corn Exchange and the new Arts Theatre and several smaller venues.

Cambridge is a city for everyone, the culture vulture, the academic, the playboy, the bibliophile, the shopaholic, the entrepreneur, the resident and the tourist. Everyone is going somewhere. Everyone is doing something. In spring the city is awash with colour, the sunlit daffodil carpets of the Backs, the fresh greensward of the lawns and parks, and the rich displays of flower beds and flower markets. Cambridgeshire has a unique magnetic appeal, from the calm, watery magic of the Fens to the gently rolling valleys of the Huntingdon Ouse and the Upper Nene. It is a county with a keen and fascinating history and one which absolutely deserves a visit.

ABOUT
THE AUTHOR

Robert Leader is a photojournalist who has written and illustrated guidebooks to Cambridgeshire, Essex, Suffolk and Norfolk. All images included in this work were taken by the author. His books for The History Press include *Bloody British History: Bury St Edmunds* and he is also the author of more than sixty published novels. For more, see www.robertleaderauthor.com